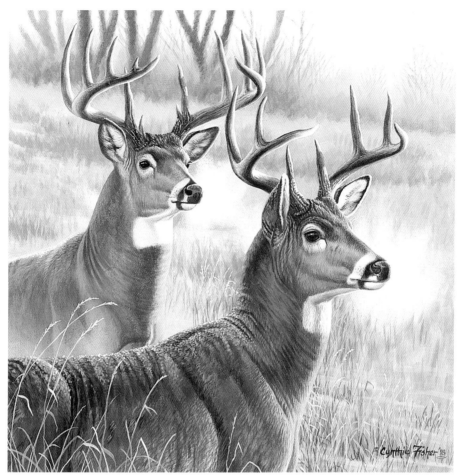

On the Alert
Acrylic on hardboard
15" × 15" (38cm × 38cm)

Wildlife

PAINTING BASICS
DEER, ANTELOPE
& OTHER HOOVED ANIMALS

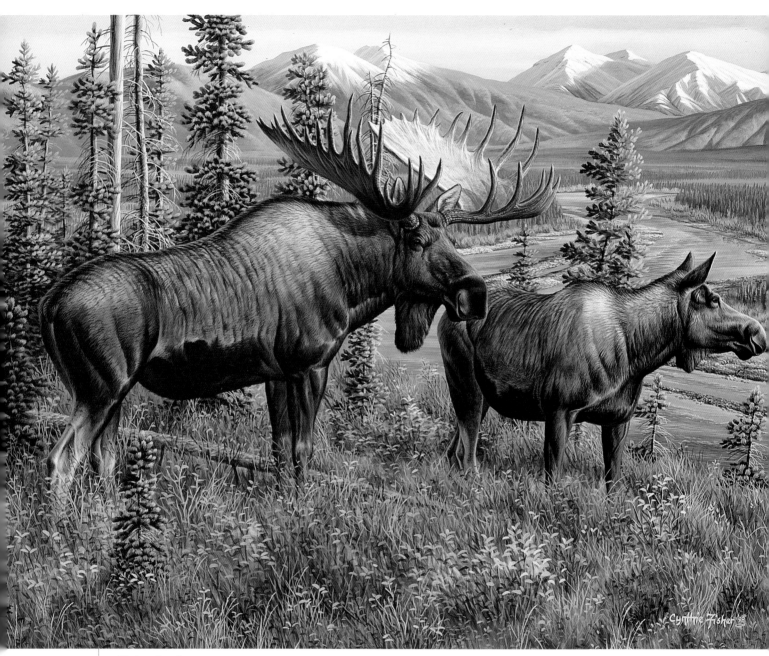

Alaskan Royalty
Acrylic on hardboard
20" × 28" (51cm × 71cm)

Wildlife

PAINTING BASICS

DEER, ANTELOPE
& OTHER HOOVED ANIMALS

Cynthie Fisher

NORTH LIGHT BOOKS
CINCINNATI, OHIO
www.nlbooks.com

Cynthie Fisher is a self-taught wildlife artist, working almost exclusively in acrylic. Planning on a career as a biologist, she graduated from Humboldt State University in northern California with a degree in zoology, but turned to the burgeoning field of wildlife art after graduation. She has painted full time for thirteen years. Cynthie also enjoys taxidermy, which helps her hone her skills and knowledge of anatomy when drawing her chosen subjects. Her favorite pastime is big-game and bird hunting, which has taken her to such exotic locations as Africa and parts of Europe and Russia. The reference she gathers on these excursions is invaluable in her artwork.

Cynthie's artistic achievements include eight state duck stamp awards, featured artist status with the Rocky Mountain Elk Foundation and the National Wild Turkey Federation, cover art for Cabela's catalog, ten-times featured artist with Ducks Unlimited, and she is a member of the Society of Animal Artists. Her work has appeared on several collector plate series, and she has illustrated for numerous magazines and field guides.

Originally from Colorado, she has recently settled in Montana, where the western landscapes and numerous deer, elk and other big-game species provide unlimited inspiration for her paintings.

Other fine North Light Books are available from your local bookstore, art supply store or direct from the publisher.

08 07 06 05 04 6 5 4 3 2

Library of Congress Cataloging-in-Publication Data
Cynthie Fisher
Wildlife painting basics: deer, antelope & other hooved animals/by Cynthie Fisher.
 p. cm.
Includes index.
ISBN 1-58180-021-5 (alk. paper)
1. Ungulata in art. 2. Wildlife art—Technique. I. Title

N7668.U44 F58 2001
758'.3—dc21 00-058219

Edited by Jennifer Lepore Kardux
Cover designed by Amber Traven
Interior designed by Brian Roeth
Production Coordinated by Emily Gross

ACKNOWLEDGMENTS

My thanks goes out to many of the students and professors in the wildlife department at my college, whose brains I picked continuously about animal behaviors, anatomy, taxidermy and correct habitats, long before I started painting. Along with their advice, I would like to thank God, who has blessed each of us with a talent, and I am so grateful that He has given me this chance to depict so many of His incredible creations. As a biologist and an artist, I am in awe of His creativity and endless variety.

And of course, I thank my editor, Jennifer Lepore Kardux, who has made this project go quite smoothly. I think we made a good team!

DEDICATION

I would like to dedicate this book to my parents, Terry and Kay Johnson. Without their continued faith and support in my pursuit of an art career, I don't think I would have gotten this far! It is such a blessing to have the encouragement and love of one's family. Although I was brought up in a big city, they never stood in the way of my relentless pursuit of the outdoors, wildlife, and the assorted animals and their parts I would drag into their lovely downtown home to study.

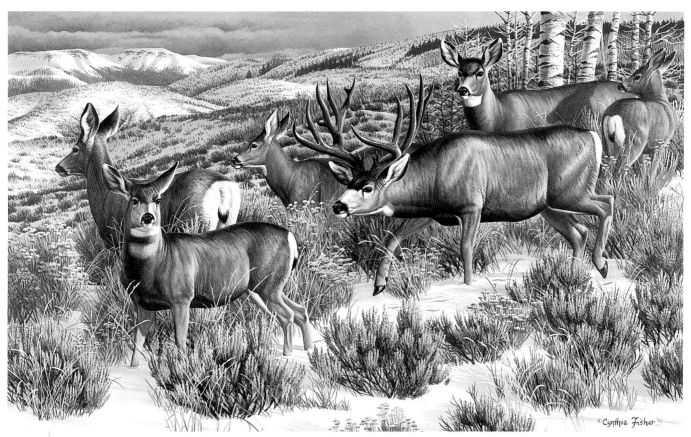

Ladies Man
Acrylic on hardboard
18" × 26" (46cm × 66cm)

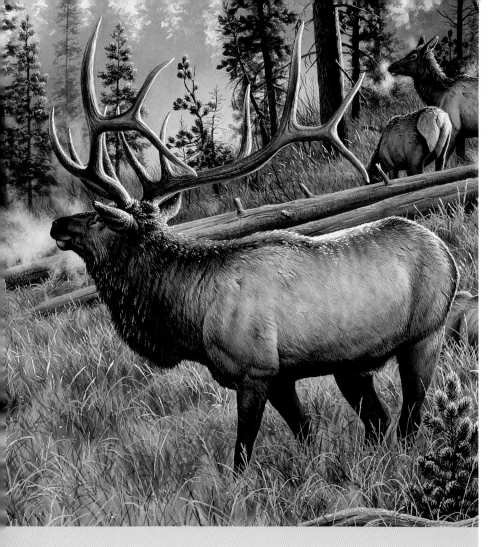

table of contents

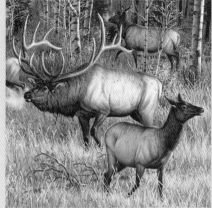
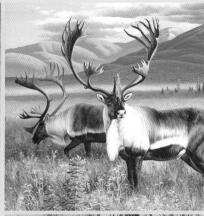

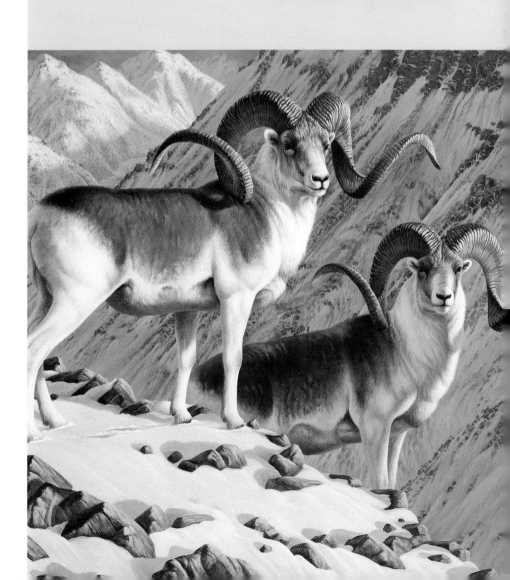

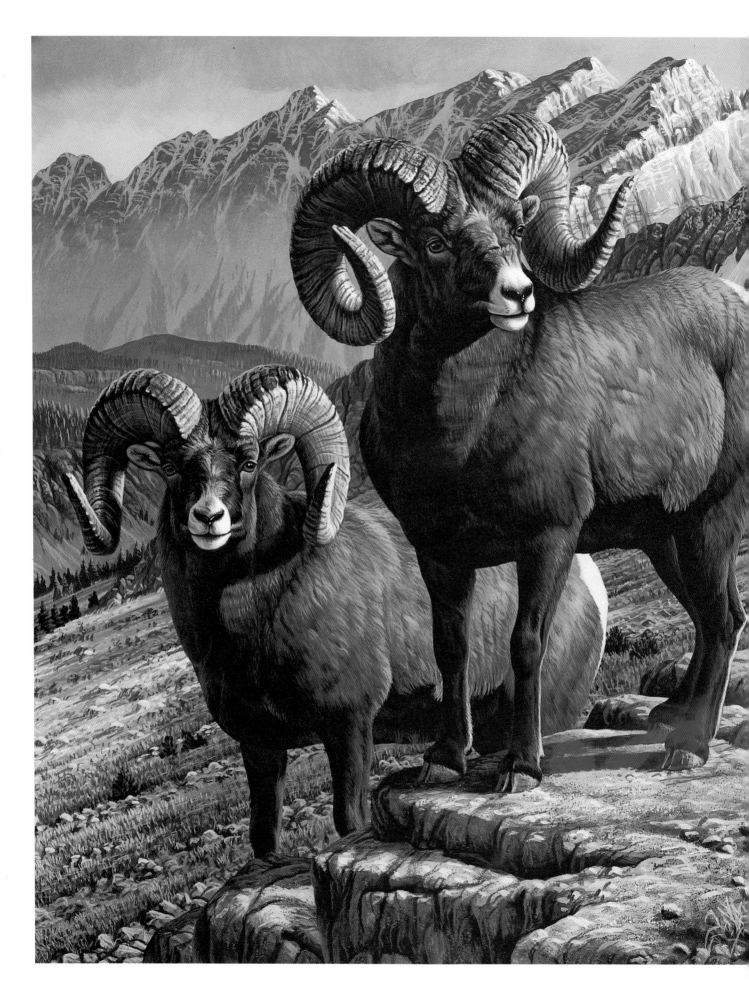

DEER, ANTELOPE & OTHER HOOVED ANIMALS

introduction

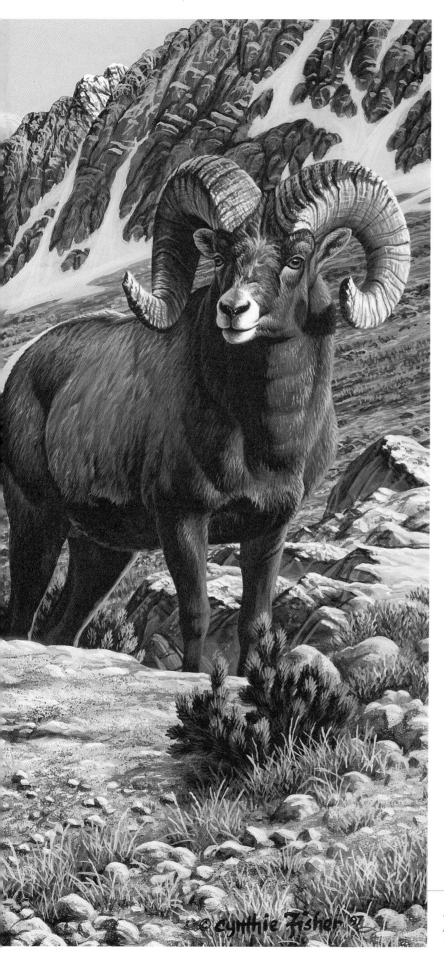

Deciding what type of animal to paint and how to go about painting it is a very individual process. Some artists gravitate toward birds and take a detailed approach, others choose a more painterly approach and focus on large mammals. Most of us try many types of subject matter, settling on the animals and the painting style we feel comfortable with, one that inspires and excites us as artists. Being comfortable generally means being confident in our ability to draw the animal correctly, and that requires a lot of study.

Along with the need for accurate anatomy of the chosen subject, the artist can greatly enhance the impact of the painting with dramatic light and bright colors. This book focuses on methods to achieve this goal, along with tips on anatomy and the many characteristics of some of the more familiar big-game species. I encourage all beginning artists in search of their own style to study the artwork of any of the more well-known wildlife artists that many of us respect. I often find myself newly inspired and creatively charged after perusing their work. It is my hope that everyone who sets out to discover their own unique talent and style will find a few tips within these pages that might help them on that journey.

Mountain Monarchs
Acrylic on hardboard
18" × 24" (46cm × 61cm)

Materials

Paint

Although I believe that drawing is the key to being a successful wildlife artist, it is very satisfying to see your drawings turned into full-color paintings.

I use acrylic paints for most of my artwork, with occasional forays into watercolor and scratchboard. Acrylics are sold everywhere in a multitude of colors and brands. I prefer Liquitex acrylics, as they seem easier to blend due to their creamy texture. Acrylics also have an advantage in being water-soluble, with no need for toxic solvents or mediums.

I don't have any hard and fast rules about what colors to use; most artists develop their own preferences on color and what works best for them. Since I want most of my paintings to have dramatic impact, I prefer the stronger pigments; you can always tone them down to a more neutral shade.

I don't use any retarding medium with my paints, preferring to use water as a thinner. I don't thin my paint very much, so that I will have less reworking to do later. I keep the consistency fairly thick and creamy with just enough water added to allow the paint to flow from the brush.

Using Acrylics

Because acrylics dry so quickly, it can be difficult to create a soft transition between areas of different colors.

Some artists mix up large quantities of each color, storing them in film canisters or jars, so they will have the right shade for the job. I prefer to remix the colors each time I need to apply the paint and use a feathery brushstroke to blend the two areas.

You will become a virtuoso at color mixing if you use acrylics consistently,

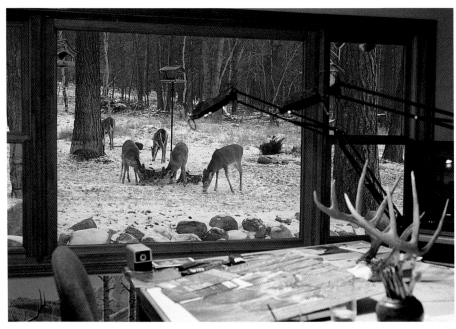

Studio
This is the view from my studio window. Sometimes it can be difficult to get any work done, with so many animals to watch!

I paint on a large drafting table, where I spread out all my reference, constantly scanning the many photos and any specimen material (note antlers), while watching videos that relate to my subject matter.

since the painted areas dry so fast, not allowing much blending on your board. Some colors will look just right as you apply them and within seconds dry to a darker tone. Acrylics also tend to look a little flat and dull until they are varnished, particularly the darker colored areas of your painting. Keep these traits in mind as you work. It may get frustrating, but there is no reason you can't achieve the same luminosity and impact that is found more traditionally with oils.

Acrylics are ideal for more detailed work, since they dry so quickly, and are well suited for depicting the level of detail and precision that many viewers and artists desire in a painting. With a little practice, acrylics lend theselves easily to many facets of wildlife art.

Palette

I use an aluminum cake pan for my palette, with several pieces of moistened paper towel underneath a sheet of 9" × 12" (23cm × 30cm) tracing paper.

I lay out my paints on the tracing paper. Because they dry so quickly, acrylics work best for me with this moist layer underneath the pigments. I do all my mixing on the palette, and after several days, when the tracing paper starts to wear thin and begins to tear, I simply throw the paper away and start with a fresh sheet. Every few hours, I rewet the paper towels, and at the end of the day, I place the palette in a plastic bag, all ready for the next day. This technique definitely saves on paint!

Brushes

Because acrylic is notoriously hard on brushes, I don't spend a lot of money on fine sable brushes! I use synthetic or a blend of natural and synthetic fibers in both rounds and flats.

My favorite brush sizes are no. 4 and no. 6 rounds, and no. 4, 6, 8, 10 and ½-inch (12mm) flats. I use these brushes for the majority of my work, along with larger flats to do the initial laying-in stage of the painting. A no. 2 round is necessary for really fine detail in eyelids and on noses, but otherwise use the largest brush you can get away with, as they hold more paint.

The brands I use vary, but I prefer Daniel Smith Series 75-01 rounds and 75-02 flats. I rarely spend more than eight dollars on a brush, and this makes it easier to throw them away once they lose their point or edge.

Painting Surface

I prefer using hardboard, or Masonite, for most of my acrylic paintings. I originally used heavy illustration board, but hardboard is much stronger and less prone to damage. I like ¼-inch (6mm) thick board for all but the largest paintings, and I have used both tempered and untempered.

The archival qualities of hardboard have been debated, and due to the fact that hardboard is made from wood, it is not acid-free. However, the application of gesso protects your painting from the acid.

I buy 4' × 8' (1.2 meter × 2.4 meter) sheets and have them cut in half at the lumberyard. I use a circular saw at home to cut them to the desired size. After some sanding on the edges and corners, I use a flat sponge brush to apply two coats of gesso, using a little water from a squirt

Work Table
Have your reference at hand while painting. Note the transfer tracing above the painting, where I can check it frequently while I work.

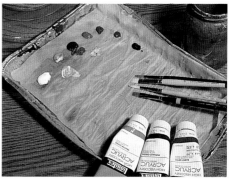

Palette
Shown here are four of my favorite brushes (no. 8 and no. 10 flats, no. 4 and no. 6 rounds) and a typical layout of my acrylic paints.

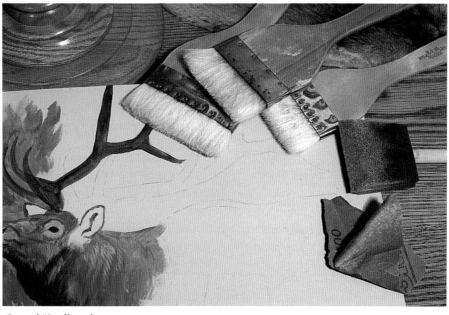

Gessoed Hardboard
Use a sponge, hake brush and sandpaper to create a smooth gray surface on the hardboard.

bottle to enhance the spreadability of the gesso. (I use only Daniel Smith Stone Gray Gesso, which I prefer to the stark white of normal gesso.)

Immediately after applying the gesso, I use a wide hake brush to smooth out the lines created by the sponge brush. This takes a light touch, but virtually eliminates the need for sanding.

I dry the board with a hair dryer, using my finger to gently rub out any hairs or clumps.

Once dry, I repeat the whole process, this time with a slightly thicker layer of gesso. After the board is dry, I lightly sand with 400-grit sandpaper, and it's ready to go! After a little practice, this technique moves quickly. You can be painting within five minutes of cutting your board.

Gathering Reference

Having the proper reference is the most important aspect of creating a wildlife painting; you can never have too much reference! If you want to be an accomplished artist with a particular subject matter, you have to do your homework. The clients you hope to impress may know more than you do about your subject matter.

You don't need a master's degree in zoology to understand animals, how they're put together, where they live and the likely behaviors you'll be painting. But you will need to start acquiring the sources that can teach you what you don't know.

Books

Most wildlife artists have libraries full of glossy coffee-table books on every animal they might find themselves painting someday.

As long as you *don't copy* the photographs you see in books and magazines with intent to sell, they are an invaluable source of ideas, details and inspiration. It is illegal to plagiarize, or directly copy, any published photo without the permission of the photographer, and there is more than one artist who has found this out the hard way!

TV and Video

With the Discovery Channel, Animal Planet and PBS broadcasting nature shows, there is a wealth of wonderful inspiration on the screen. Interpreting it on your board can be a bit tricky.

Sketching from TV broadcasts is easier if you tape the program and play it back, pausing it and slowly

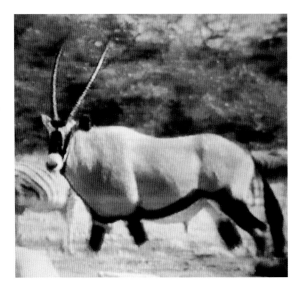

Photo From TV
Although a bit blurry, this photograph of a gemsbok antelope in Africa, taken from a nature show on TV, contains a lot of information about anatomy, lighting and habitat. Color is usually secondary in TV photos. This photo shows the overall proportions and muscle tone of this antelope.

advancing, frame by frame, until the angle you want is displayed.

It is also possible to take photos directly from the TV. Using a tripod in a darkened room, load your camera with 200 ASA or higher speed film, position the camera so the TV screen fills the viewfinder and experiment! Shutter speeds will be slow and the color isn't great. What you'll get is just a gesture or pose, but it can be the germ of a really great composition.

Photography

Taking your own reference photos can be more fun than actually painting the final product. In the case of big-game animals, spending time in their environments is a wonderful excuse for a vacation! Most of these species look their best in the fall, when the foliage is spectacular, the mountains are snow-capped and the air crisp and clean.

Because the chances of getting a full-frame photo of a big whitetail or moose aren't great, many artists opt to purchase their reference from professional wildlife photographers. You'll be paying anywhere between ten and five-hundred dollars per slide.

While an easy shortcut, this method doesn't allow you to experience where the animal lives. The photos you take of a habitat are just as valuable as those of your subject. You will have memories wrapped up in taking your own photos that will aid you immensely once you decide to put your experience down in paint or pencil.

Don't be a slave to your reference; the photos exist to enhance or inspire your artistic ideas, not to dictate how creative you can be. You'll soon learn to take your camera everywhere with you, and you'll be surprised how many wonderful opportunities will come your way, especially once you train yourself to watch for good lighting and habitat details. Every tree and rock has potential!

Photography Equipment

A 35mm camera is a must for photographing big-game animals, along with several lenses, such as a 28-80mm zoom, a 100-300mm zoom and maybe a larger 400 or 600mm lens as well. If you choose to work from many sources at once, print film works the best, although slides have better color.

Remember, film is cheap, so shoot lots of it! Look for different situations involving lighting on your subject matter and the background, as this is one of the most critical areas in creating a successful painting. Photos never capture the light and color exactly as you see it, but that's one of the perks about being an artist; it's all up to you!

Sketching

Nothing can familiarize you better with your subject than sketching the animal in the flesh. This can be problematic with some species, but you must become familiar with the basic structure of big-game animals if you want to paint them successfully. Zoos are wonderful places to study many species in one session, and you will be amazed at how similar most antelope, sheep and deer are in their basic anatomy.

Sketching has the wonderful ability to help you commit the details to memory, much more than simply taking a quick photograph.

Getting started with big game may seem daunting, but there are ways to make it easier. You can start with tracing photographs from books or magazines, purely for study, until you feel comfortable enough to draw the animals freehand. Once you have knowl-

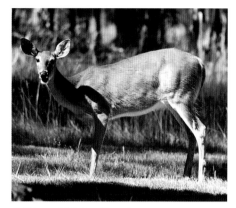 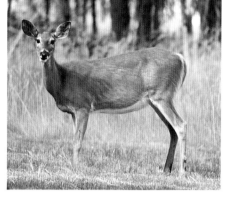

Different Lighting Situations
It's always interesting to observe how different lighting can dramatically impact a scene. These photos show the difference between strong sunlight and an overcast sky on the same subject. Each situation has rewarding aspects to ponder when deciding light direction in a painting.

Background Reference
This photo is a sample of a good comprehensive shot that includes the color of the deer in this type of light and the type of trees and values that you see at this time of day.

Close-Up Reference
Taken at sunset, this photo is a little out of focus, but it shows the warm colors that result during the last few minutes of sunlight. You will have to integrate these close-up photos with the animals and backgrounds you choose to paint, matching the light angle and intensity.

edge of a deer or an elk's structure, for example, you can make use of what you see at the zoo or museum. Museums are good places to sketch, as are taxidermist studios, since the animals are stationary. Other good sources of "stationary" reference include hunters and even roadkills. (Although dead animals may not be appealing, they are an age-old source for artists; it worked for Audubon and Rungius!)

Reference Sources

university collections
zoos and museums
biologists and game wardens
hunters
roadkills
taxidermists
other artists
game farms

How to Use References

Going from your references to a large painting can seem a daunting task!

Sketch Your Composition

It helps to start off the painting process with thumbnail sketches. It is important that your sketch has a pleasing composition and fairly accurate anatomy. It is far easier to correct any flaws at this stage while the drawing is small!

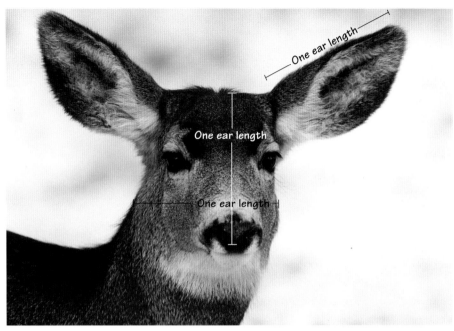

Rough Measurements

Using a ruler or your pencil, determine some proportions by measuring the length of a prominent feature, such as the ear on this mule deer doe. Once you have that length, use it to check the proportions on your own sketch. In this case, one ear length on this mule deer equals the width of the head through the nose, as well as most of the length of the face.

The Importance of Sketching

The number one piece of advice is sketch, sketch, sketch! If you can create a good representation of an animal through your own observation and freehand talent, there is no limit to the creativity and enjoyment you can derive from painting.

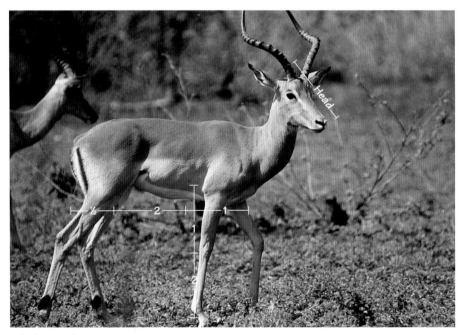

Checking Body Proportions

With this impala, his head length is used to determine the rough scale of his body. His leg length equals two head measurements, and his body length comes out roughly at two-and-a-half head lengths. Practice this technique to help you keep on track when you're sketching game animals, stopping often to check your proportions. Make sure your photos aren't distorted.

Transfer Your Sketch

If your painting is going to be large, you can use an Artograph projector to project your sketch onto tracing paper taped to your gessoed board. (This saves a lot of time, although you do learn a lot by enlarging your sketch freehand!) If your drawing is too big to place in the projector, try reducing the size on a photocopier or fax machine before fitting it into the Artograph.

If your sketch and painting are going to be the same size, you can transfer your sketch to your painting surface with a "carbon paper" method (see sketches on this page for more details).

Common Transfer Errors

When using "carbon paper," flip the paper over often; you will be amazed at how many mistakes you will pick up by looking at the drawing in reverse! Common ones I find include eyes that are not aligned, one ear bigger than the other, skewed antlers. Your brain tends to draw one side of the animal better than the other, but by looking at the reverse of the image, you will be able to correct these mistakes.

Work on Your Sketch
After preparing your board, tape down a piece of tracing paper to it and work on your sketch, keeping all your references close by. The level of detail at this stage is up to you. I prefer to keep it loose, allowing for spontaneity later during the painting process.

Make "Carbon Paper"
Once you have the drawing to your satisfaction, apply a layer of charcoal or soft pencil to the other side of the tracing paper, directly over your drawn lines. This will be your "carbon paper," and as you transfer your drawing onto the gessoed board, it will leave a nice outline for you to follow when you begin to paint.

Transfer Your Sketch
Carefully place the tracing paper on your board, using tape to keep it in the right spot. Use a hard 4H pencil to transfer the design. If you need to draw in every detail, try to keep your transfer lines on the light side. I prefer to transfer a minimal amount of detail at this stage, allowing the brush to define what is needed at the painting stage. Reposition any elements of the drawing that aren't exactly where you want them.

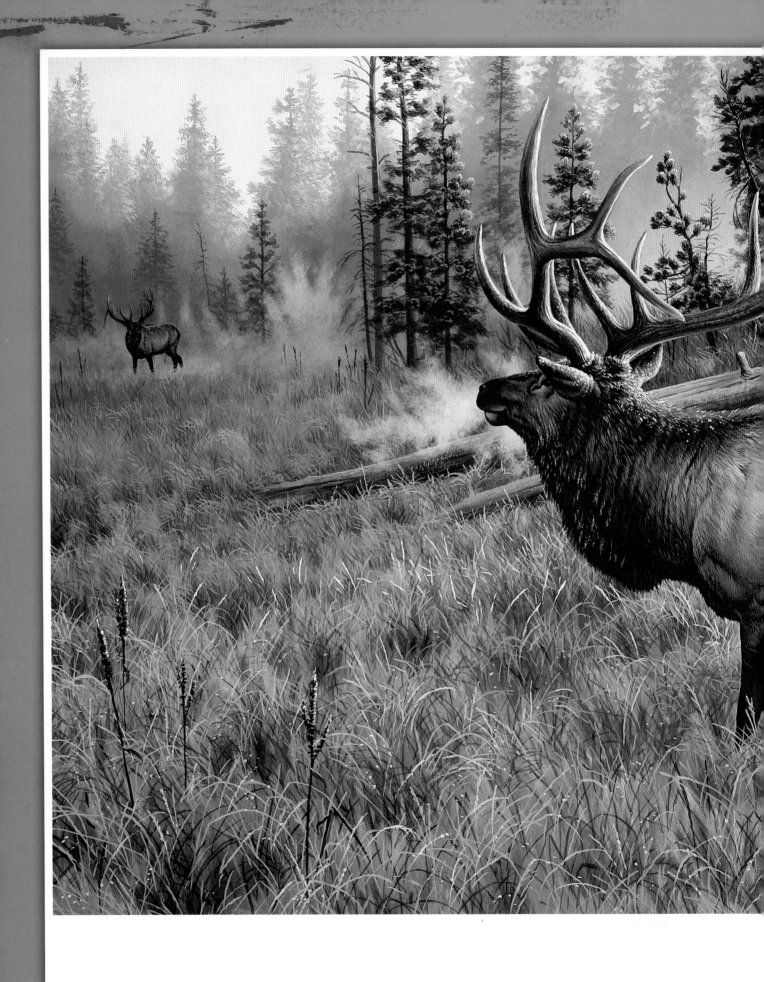

A Worthy Opponent
Acrylic on hardboard
18" × 24" (46cm × 61cm)
Private collection

BASIC STRUCTURE *and* ANATOMY

Before you set out to paint a big-game animal, there is a lot of study and observation that must take place. The success of your efforts will rely in a large part on your knowledge and mastery of that animal's anatomy.

Although there are many aspects that contribute to the creation of a beautiful painting, your successful rendition of an animal's likeness ultimately depends on whether you succeed in portraying that animal correctly.

What follows is a selection of species, illustrating the defining characteristics of each. Not every big-game animal is represented, but you'll find many of the more popular species that you might be painting one day!

Understanding How Hooved Animals Are Built

To be able to sketch big-game animals successfully, you need a working knowledge of how they are put together, and the various elements of bone, muscle and features that define them.

By understanding their structure, you will be able to sketch animals in almost any pose, augmenting your photo reference with your ability to position the animal in a pose that works best for your painting. This freedom to sketch without directly copying a photo is a wonderful tool for an artist, but it can only be achieved with a lot of study and an awareness of anatomy.

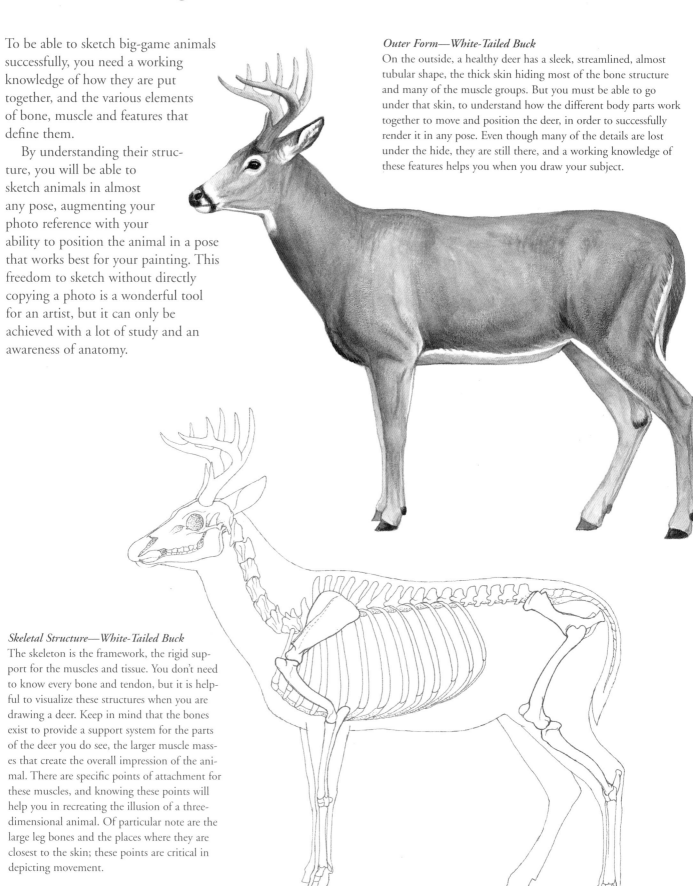

Outer Form—White-Tailed Buck
On the outside, a healthy deer has a sleek, streamlined, almost tubular shape, the thick skin hiding most of the bone structure and many of the muscle groups. But you must be able to go under that skin, to understand how the different body parts work together to move and position the deer, in order to successfully render it in any pose. Even though many of the details are lost under the hide, they are still there, and a working knowledge of these features helps you when you draw your subject.

Skeletal Structure—White-Tailed Buck
The skeleton is the framework, the rigid support for the muscles and tissue. You don't need to know every bone and tendon, but it is helpful to visualize these structures when you are drawing a deer. Keep in mind that the bones exist to provide a support system for the parts of the deer you do see, the larger muscle masses that create the overall impression of the animal. There are specific points of attachment for these muscles, and knowing these points will help you in recreating the illusion of a three-dimensional animal. Of particular note are the large leg bones and the places where they are closest to the skin; these points are critical in depicting movement.

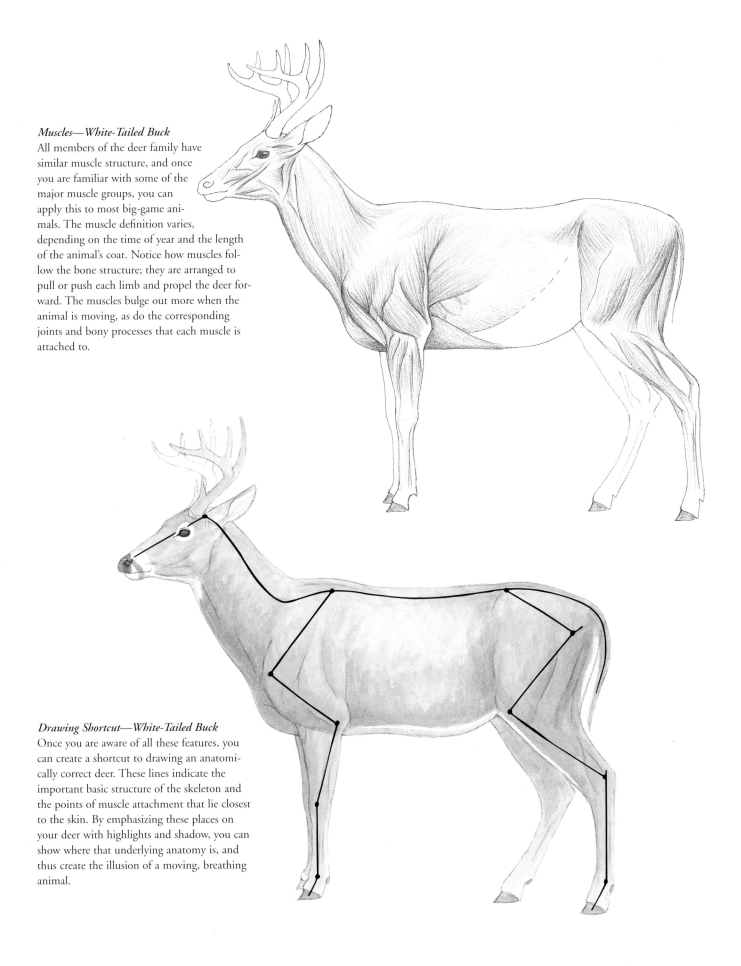

Muscles—White-Tailed Buck
All members of the deer family have similar muscle structure, and once you are familiar with some of the major muscle groups, you can apply this to most big-game animals. The muscle definition varies, depending on the time of year and the length of the animal's coat. Notice how muscles follow the bone structure; they are arranged to pull or push each limb and propel the deer forward. The muscles bulge out more when the animal is moving, as do the corresponding joints and bony processes that each muscle is attached to.

Drawing Shortcut—White-Tailed Buck
Once you are aware of all these features, you can create a shortcut to drawing an anatomically correct deer. These lines indicate the important basic structure of the skeleton and the points of muscle attachment that lie closest to the skin. By emphasizing these places on your deer with highlights and shadow, you can show where that underlying anatomy is, and thus create the illusion of a moving, breathing animal.

Studying Anatomy Through Photos

You can outline the basic positions of an animal's limbs using your own reference photos or those you collect from other sources. Practice looking at a reference photo and recognizing the anatomy that lies beneath the skin and the way the skeletal structure and muscles combine to create that animal's form and sense of movement.

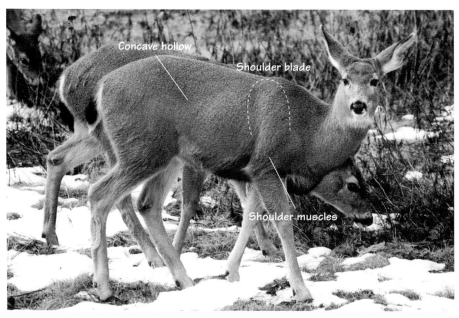

This black-tailed doe is a good study of the basic muscle and joint structures. By looking at the diagram of the skeleton on page 18 , you can better understand the slight concave hollow in front of her pelvis, where there are no bony structures, and the hump of her shoulder blade. Notice the indication of the more prominent "shoulder" muscles; indicating these in your painting helps your deer look more alive.

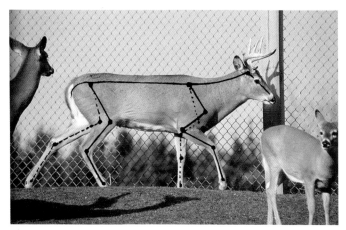

This white-tailed buck is in motion, and while most of his muscle tone is hidden by his hide, you can still draw an outline of his major joints and spine, indicating those points of muscle attachment.

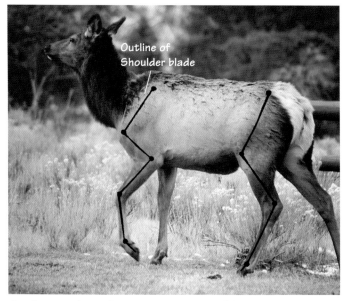

Caught in another walking position, this cow elk has good muscle tone, and her left front leg, caught in midstride, clearly shows the position of the shoulder blade. It is worth remembering that the shoulder is not attached to the rest of the skeleton, but floats free from the spine, to aid in movement.

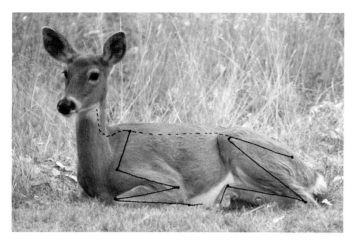

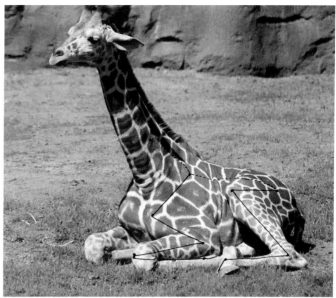

Once you become aware of the skeletal and muscle structures, it is easier to sketch many different species of hooved animals, noting the basic anatomical similarities.

Here are two very different species, a whitetail and a giraffe, reclining in the same pose. Note how they fold up the front and hind legs in the same manner, differing only in proportions. Try drawing a line diagram to show the major joints and leg bones for your subjects.

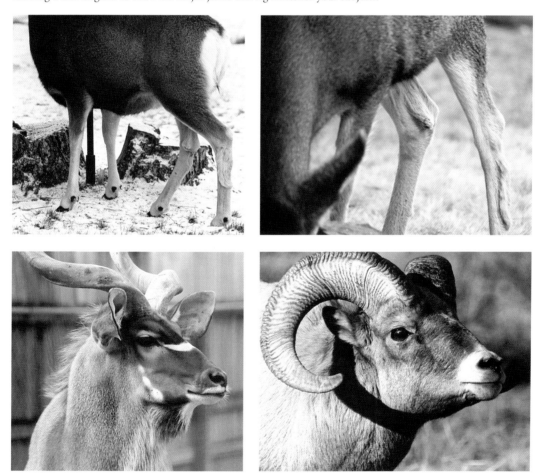

Close-Ups
Don't forget to zoom in on your subjects and get as much information as you can on isolated parts of their anatomy, such as feet, legs, ears, eyes and horns. It's best to do some sketches, too, to solidify these structures in your mind, but it doesn't hurt to take as many photos as you can to help you later as you paint these details.

White-Tailed Deer

The whitetail is probably the most commonly painted big-game species in North America, and a plethora of reference exists on these beautiful animals.

Whitetails tend to be various shades of brown, depending on the season and part of the country where they live. Their characteristic look includes a shapely, refined head, smaller ears and distinctive white markings on the face and neck.

Whitetails have large dark eyes, accentuated by pale eye markings and a prominent eyelid, which adds to their "doe-eyed" look. Their ears are relatively small and delicate, with paler markings than the mule deer (see opposite page). The antlers of the bucks are characterized by having straight tines that project from a curving main antler beam.

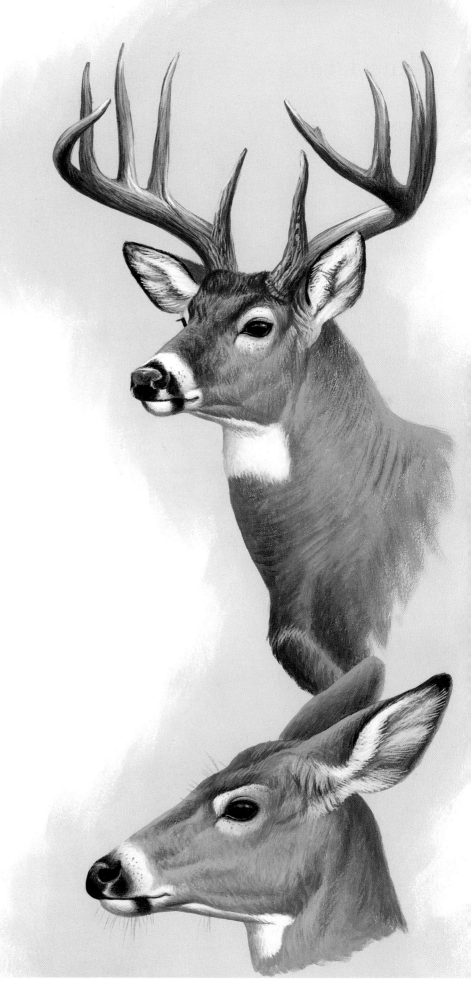

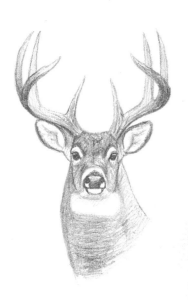

Mule Deer

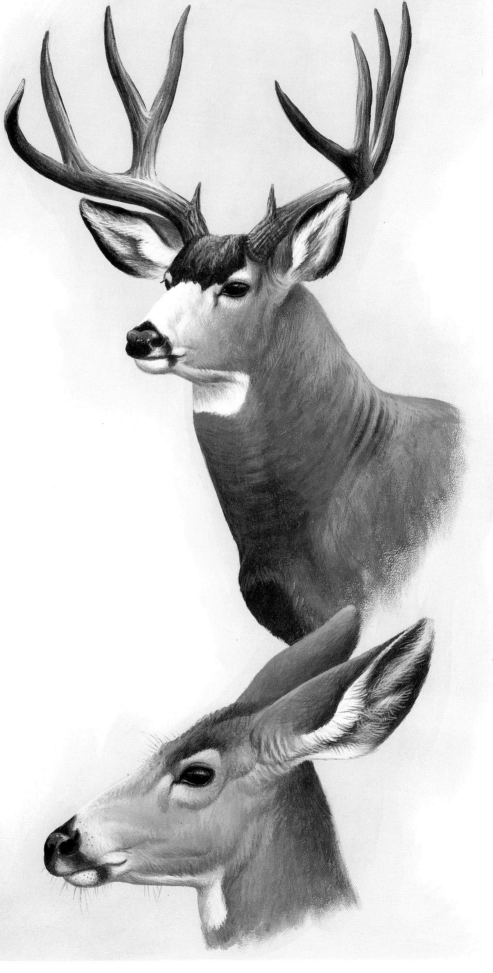

Mule deer are much less cosmopolitan than the whitetail in their choice of where they live, and are built for the rugged western landscapes they prefer.

These deer appear much grayer in color than whitetails, especially in fall and winter. They tend to be a bit larger and more robust than whitetails, with slightly heavier features.

The most prominent feature that sets mule deer apart from their kin is their large ears, for which they are named. When viewed head-on, a mule deer's wide ears and characteristic dark forehead patch usually make identification easy.

Mule deer have a white throat patch and darker muzzle markings.

The buck's antlers branch into tall forks above the main beam and can grow quite wide.

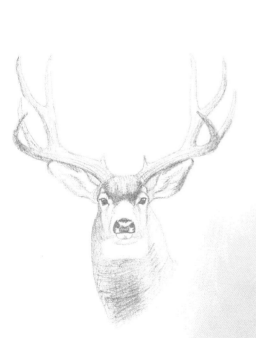

Comparing Other Features

You can't just change the head and antlers when you are painting different species; there are other differences to be taken into consideration.

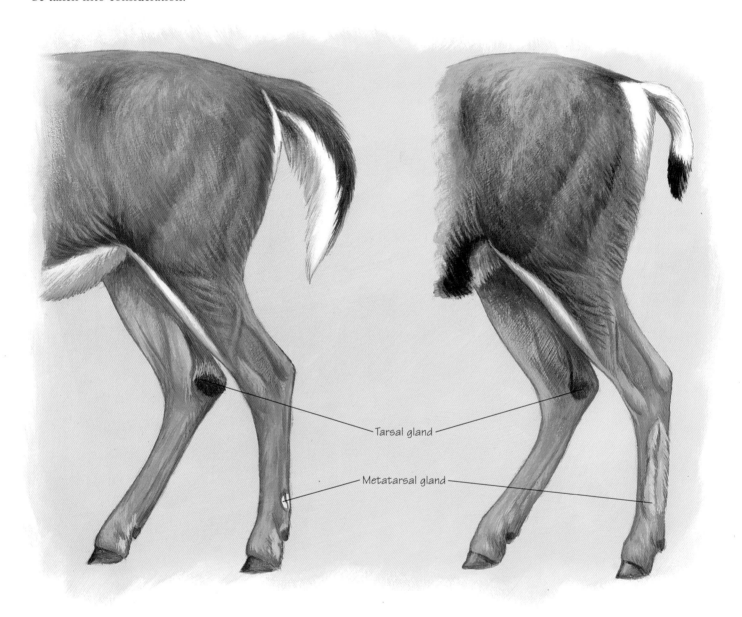

Tarsal gland

Metatarsal gland

White-Tailed Deer—Hind End
A whitetail has a big, flashy tail which the deer waves back and forth when running from danger, a signal to other deer in the area that there's trouble approaching. These deer have a prominent tuft of hair on the inside of the hock, called a "tarsal gland," which can become quite dark and stained with urine that the deer rub into the hair to use as a scent signal. Bucks in particular have prominent glands. There is also a small white patch on the outside of each hind leg, called a "metatarsal gland," which is quite small in whitetails.

Mule Deer—Hind End
A mulie's tail is rather small compared to a whitetail's, and it isn't used to signal danger. Instead, the whole rump is white and is often the only easily visible part of the deer at long ranges. The tail is tipped in black in the mountain populations, gradually turning all black near the Pacific coast, where mule deer are replaced by the elusive black-tailed deer. Mulies also have tarsal glands, generally not as large as the whitetail's, and an enormous metatarsal gland, which is an important feature to include when drawing these deer.

Changing Angle of View

One of the more challenging tasks in drawing an animal is changing the angle of view. This requires a good understanding of the anatomy as you rotate the body and legs to create a more dramatic pose.

As you draw your subject from different points of view, keep the basic tubular body shape in mind, think about the joint placement and where those points would be at that angle, and imagine the muscles and limbs and how they would appear from behind or in front.

Use a lot of references! Even photographs of horses and dogs can help you in understanding what is going on with the leg joints from some of these angles, as these structures are very similar. Deer species are quite narrow when viewed from the front or back; this shape facilitates their lifestyle of escape and blending in and allows for greater freedom of movement of their limbs.

The basic structure of mule deer and white-tailed deer legs is very similar with regard to joints and muscles, with the major differences reflected in the glands and their placement. Viewed from the back, the large tail and absence of white rump define a whitetail, but the basic anatomy is very similar to a mule deer. A large mule buck can seem almost stocky by comparison to the whitetail, but deer vary tremendously.

Elk

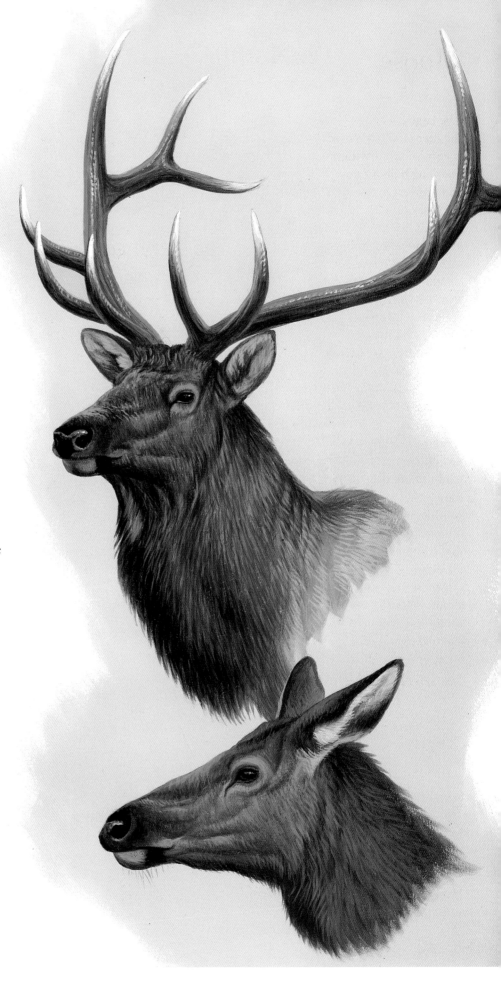

Generally regarded as the king of North American big-game animals, the regal elk has the headgear to match; a pair of branched, typically six-point antlers that can span up to five feet in width.

Elk evolved for a life on the plains and prairies, but they have been slowly pushed into the backcountry by pressure from human intrusion.

They are large animals, standing four to five feet (1.2 meters to 1.5 meters) at the shoulder, and are adorned in attractive, two-tone coats, with dark bellies, legs and faces, and a beautiful pale golden body color. Due to their coloration, they are generally not mistaken for any other species of deer. They have long, shapely legs and are generally more heavily built than their lighter deer cousins.

Elk are one of the more social members of the deer family, and the cows can form large groups, which the bulls spend a lot of time trying to impress every fall. These rituals form the basis of most of the paintings seen today of these majestic animals.

Moose

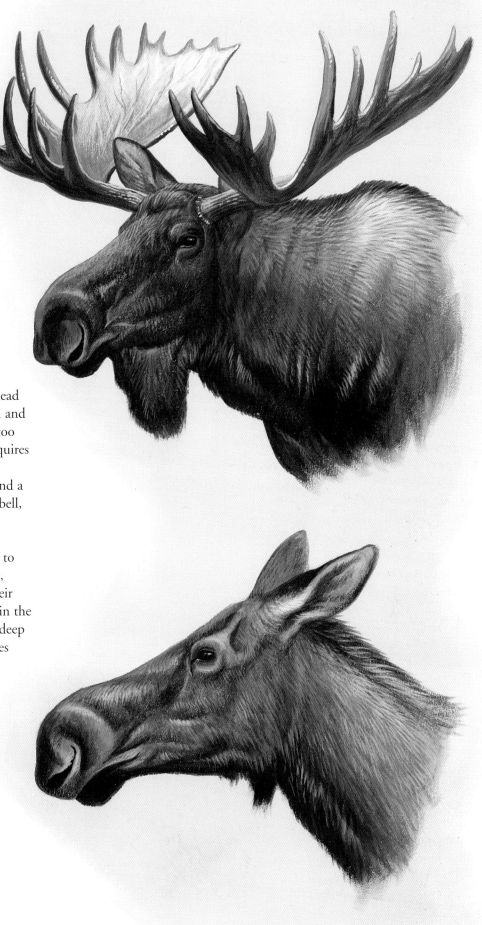

The largest member of the deer family, a moose is unmistakable, with that long bulbous nose and impressive size; a big bull can weigh in at fourteen hundred pounds and stand seven and one-half feet (2.3 meters) at the shoulder, with antlers over six feet (1.8 meters) wide. There are several subspecies of moose, which vary in size: The woodland, or Shiras, moose found in the Rocky Mountain states is generally smaller than a huge Alaskan specimen.

The structure of the moose's head is quite different from other deer, and luckily, reference photos are not too hard to find, because the nose requires some study, as do the antlers.

Moose have rather large ears and a unique flap of skin and hair, the bell, that hangs under the jaw (this is largest on the bulls).

Moose are usually dark brown to almost black, with pale, long legs, much longer than other deer. Their legs make them look quite short in the body, but serve them well in the deep willow thickets and boggy marshes where they live.

Caribou and Pronghorn Antelope

Caribou

Caribou are always on the move, and they easily cover hundreds of miles of their tundra and boreal forest habitat during their epic migrations.

Caribou are one of the flashiest, most impressive members of the deer family with their incredible antlers and multicolored coats.

Their huge antlers seem superfluous but do the job in showing the females which bull is the fittest.

Caribou have long furry muzzles, an adaption to the cold winter air. Their coat coloration varies widely, from being almost black to a two-tone brown or pale fawn gray.

Pronghorn Antelope

While not a deer, pronghorn are unique among grazing animals, as they are the only antelope that annually shed their horns, growing new ones each spring. Females, too, can have very tiny horns and lack the distinctive black facial markings of the bucks. Pronghorn are built for speed, with a very streamlined shape and slender legs, as well as strong muscles for running; they are the fastest land animal in North America.

These antelope can be seen from a long way off, due to their striking white and tawny coat patterns. The buck spends most of his time in the fall defending a patch of territory, trying to keep any wandering females from leaving his area.

Pronghorn have incredible eyesight and use their bright white rump patch to signal danger across long distances.

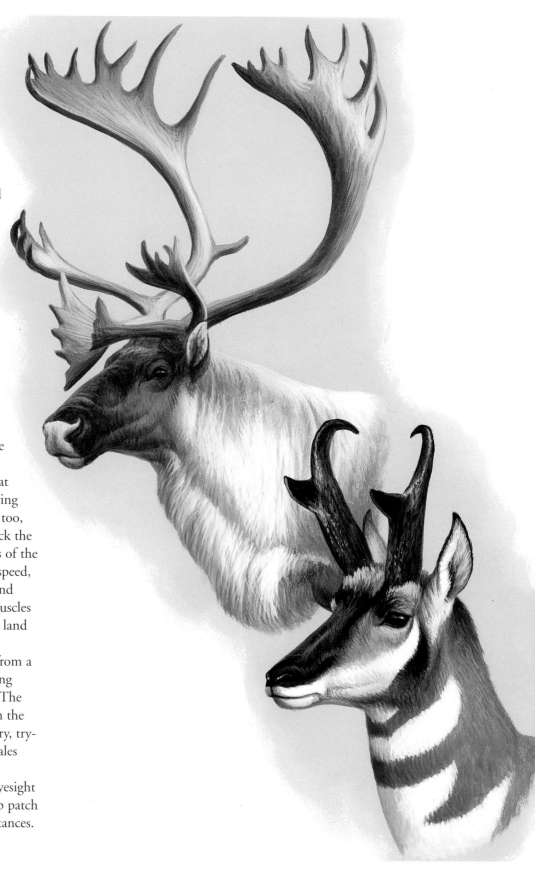

Bighorn Sheep and Mountain Goat

Bighorn Sheep

The regal bighorn ram is one of the most impressive of our native big-game animals, with his heavy crown of golden, curling horns and his lofty habitat.

Bighorns live in many western states, traversing steep shale slopes and canyons with ease. There are two main types of wild sheep in North America—bighorns and thinhorns—with many subspecies and population differences, but the Rocky Mountain bighorn is perhaps the easiest to observe.

Sheep enjoy each other's company, living segregated in small bands of males and females until mating season, when the largest rams descend from the peaks to challenge each other and breed with the ewes. Their horn-bashing fights can be heard for miles and often result in broken noses and chipped or broken horns for many of the rams.

Mountain Goat

These tough creatures live in even steeper terrain than the mountain sheep and somehow eke out a living on the sparse grasses found on these cliffs and mountaintops. Their horns are modest, but sharp, and the billies use them on each other in their mating duels. The nannies have horns too, and a reputation for an ornery nature.

Goats have very dense coats to combat the elements in their environment and rubbery inner soles on their hooves to cling to the steep rock faces. There are no dramatic head-butting rituals among goats; they take their time, treading cautiously around each other, as one false step can spell disaster. They live in small family groups or alone and don't have much to fear from predators in their lofty domain.

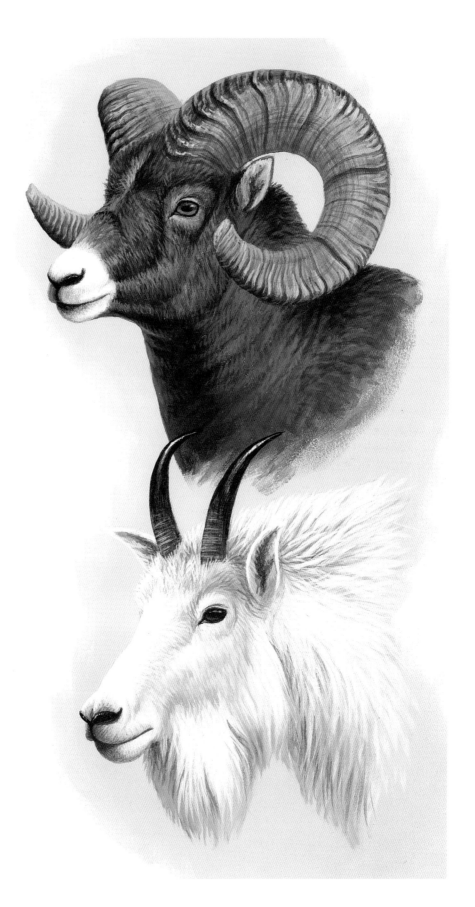

More Hooved Animals

The things you learn by studying and sketching hooved animals will open a whole world of possible subjects for you. There are so many wonderful, colorful, interesting species, with a lot of anatomy in common. You will be able to apply much of what you see in a deer's shape to a kudu or an impala, and vice versa. Many African species make ideal study subjects, with their shorter coats and more defined anatomies. Once you have a handle on how they're built, you can start the fun job of learning more about their behaviors and habitats, so you can paint them in a proper setting. Try to sketch as many different species as you can; you will learn so much from each one!

Reticulated giraffe

Siberian ibex

Impala

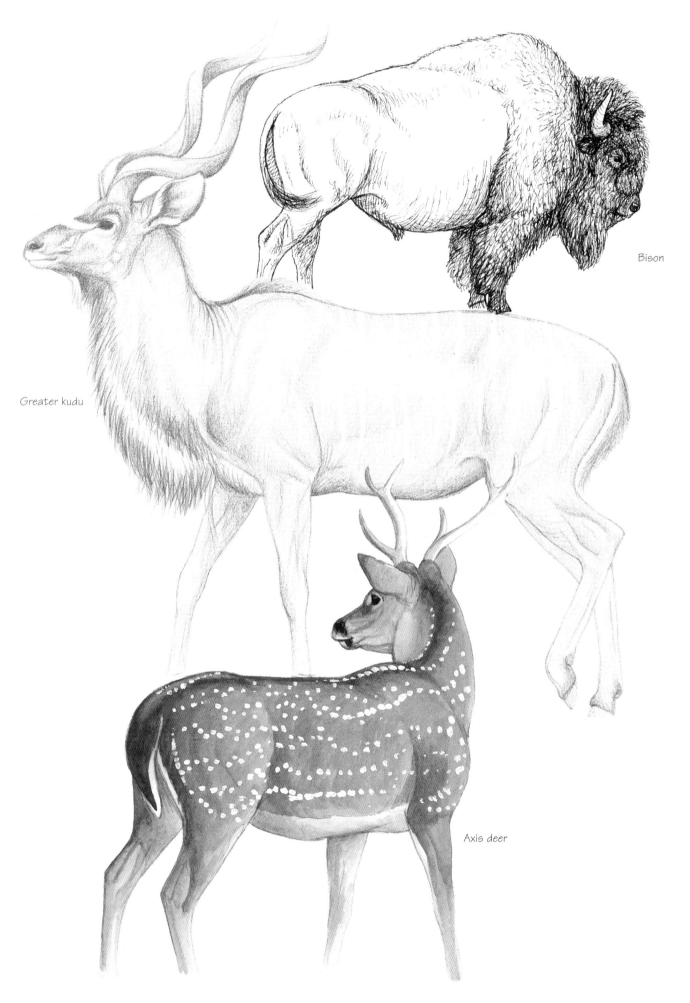

Bison

Greater kudu

Axis deer

Cautious
Acrylic on hardboard
17" × 26" (43cm × 66cm)
Private collection

2

WHITE-TAILED DEER

It isn't too hard to find out about whitetails. Their image graces the covers of most hunting magazines. There are a multitude of videos that show their behaviors and habitat, as well as dozens of books filled with photos of whitetails in every pose and environment.

To become efficient at sketching and painting whitetails, take advantage of some of these reference sources to learn about whitetail anatomy and behavior. Deer can be difficult to sketch in the field, but whitetails are easy to bring in to range in certain areas with feeding stations, and they habituate quickly to human presence.

Action and Behavior

Deer in action are a bit more difficult, but with these simple guidelines, you can position the deer's legs and body to accurately portray movement.

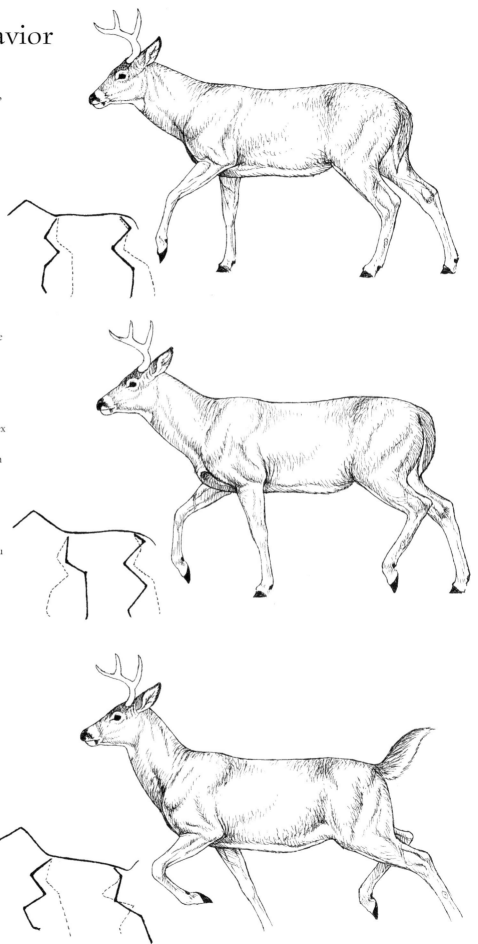

Walking and Trotting

When walking, a deer moves the opposite front and rear legs in a tandem manner, with the legs mirroring each other as they move. Deer do not pace (move both legs on the same side of the body at the same time); only a few large mammals pace, such as giraffes and camels.

In the basic line structures here, note the sharp angles at the shoulder, elbow, hip and knee joints. These indicate where the joints flex and the larger muscles attach, so it is a good idea to always keep these points in mind when portraying a deer in action. You can see here that the major muscles follow these lines and become more prominent as the deer increases his rate of speed. Once he starts jumping or fighting, these muscles really begin to stand out. Look carefully at your reference when you are drawing deer in action!

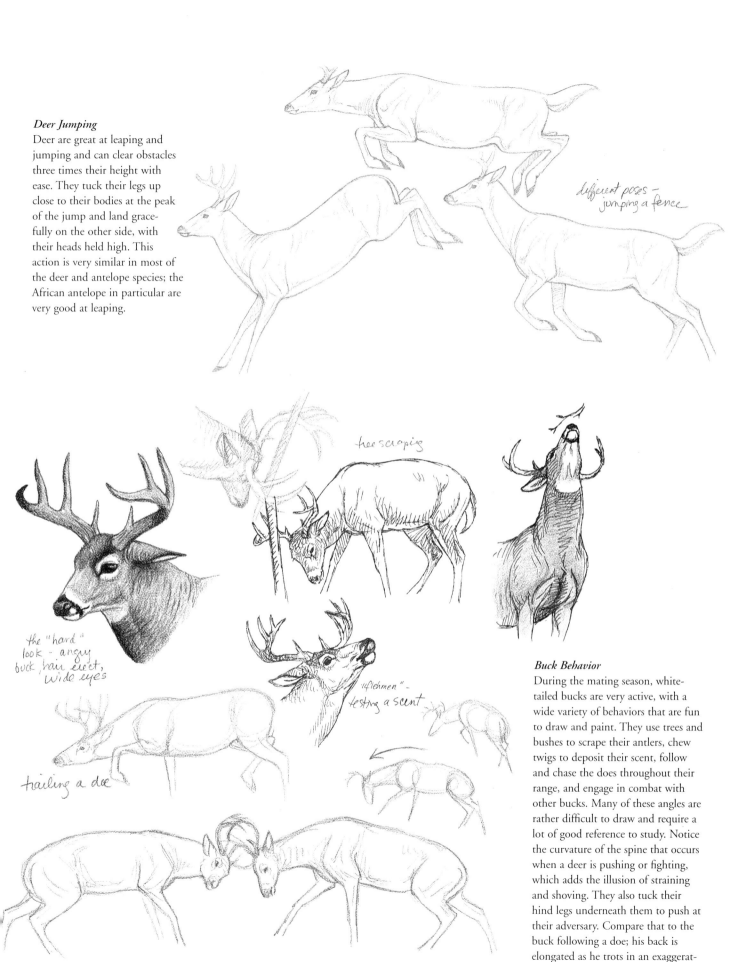

Deer Jumping

Deer are great at leaping and jumping and can clear obstacles three times their height with ease. They tuck their legs up close to their bodies at the peak of the jump and land gracefully on the other side, with their heads held high. This action is very similar in most of the deer and antelope species; the African antelope in particular are very good at leaping.

different poses — jumping a fence

tree scraping

the "hard" look — angry buck, hair erect, wide eyes

"flehmen" — testing a scent

trailing a doe

Buck Behavior

During the mating season, white-tailed bucks are very active, with a wide variety of behaviors that are fun to draw and paint. They use trees and bushes to scrape their antlers, chew twigs to deposit their scent, follow and chase the does throughout their range, and engage in combat with other bucks. Many of these angles are rather difficult to draw and require a lot of good reference to study. Notice the curvature of the spine that occurs when a deer is pushing or fighting, which adds the illusion of straining and shoving. They also tuck their hind legs underneath them to push at their adversary. Compare that to the buck following a doe; his back is elongated as he trots in an exaggerated manner. Deer are very flexible!

Painting a White-Tailed Buck

Painting a big, impressive white-tailed buck in full glory is usually a goal for any artist interested in deer! This is a good introduction to the methods to use when painting any big-game animal, since they share many traits in common.

Notice that in this piece, there really isn't a lot of "painting hairs"—deer certainly have lots of hair, but it tends to lie down smoothly in a thick coat and isn't well-suited to a hair-by-hair approach. The trick is to indicate a few hairs here and there and let the imagination fill in the rest!

MATERIALS

Surface
Gessoed hardboard
 panel

Paints
Burnt Umber
Burnt Sienna
Raw Sienna
Yellow Oxide
Ultramarine Blue
Phthalo Blue
Payne's Gray
Titanium White

Brushes
Round: no. 2, no. 4,
 no. 6
Flat: no. 3, no. 6

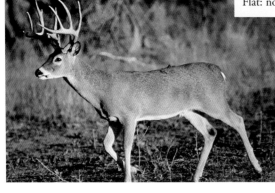

Reference Photos
These photos show how different pictures can help with different parts of a painting: The photo at above, bottom shows great color; the photo above, top shows lighting and anatomical details.

Step 1: *The Initial Sketch*

Make a few thumbnail sketches of deer, trying out different angles and poses. If something grabs you, work on it further, keeping it fairly simple at this stage.

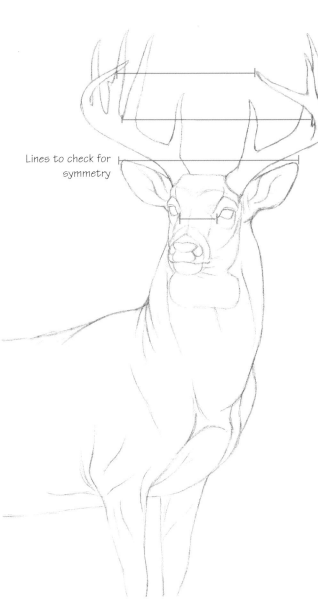

Lines to check for symmetry

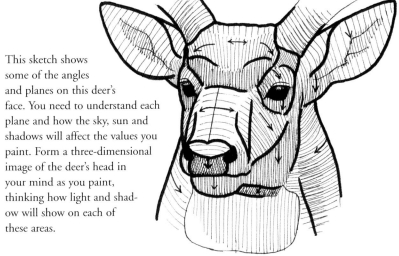

This sketch shows some of the angles and planes on this deer's face. You need to understand each plane and how the sky, sun and shadows will affect the values you paint. Form a three-dimensional image of the deer's head in your mind as you paint, thinking how light and shadow will show on each of these areas.

STEP 2: *Making the Transfer*

Carefully draw the deer to size on your tracing paper, indicating the major muscle groups, anatomy and facial features. Use your pencil to take a rough measurement of one of the deer's features, such as an ear, and use that length as a guide for other points, such as the width of the neck, the width between the eyes, the length of the antlers.

STEP 3: *The First Layer*

Determine the source of light in your painting. Here, the sun is low, coming from the left.

Use a no. 3 flat or no. 4 round to paint smaller areas, like in the ears, and a no. 6 flat or no. 6 round to paint the neck and shoulder.

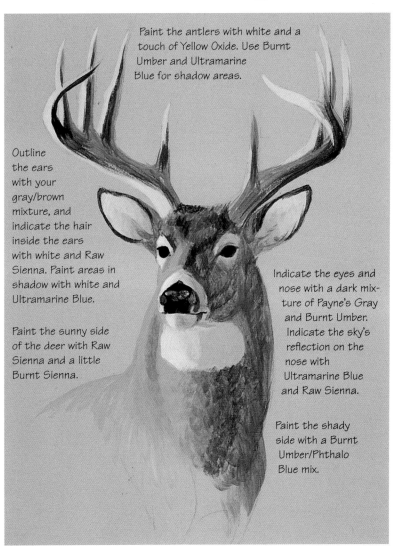

Paint the antlers with white and a touch of Yellow Oxide. Use Burnt Umber and Ultramarine Blue for shadow areas.

Outline the ears with your gray/brown mixture, and indicate the hair inside the ears with white and Raw Sienna. Paint areas in shadow with white and Ultramarine Blue.

Paint the sunny side of the deer with Raw Sienna and a little Burnt Sienna.

Indicate the eyes and nose with a dark mixture of Payne's Gray and Burnt Umber. Indicate the sky's reflection on the nose with Ultramarine Blue and Raw Sienna.

Paint the shady side with a Burnt Umber/Phthalo Blue mix.

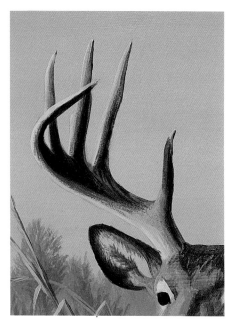

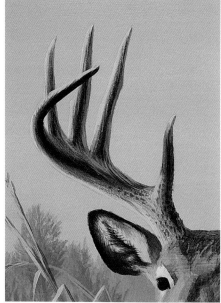

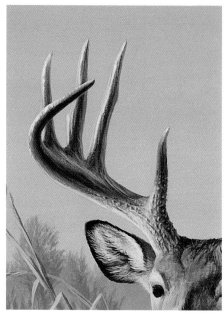

STEP 4: *Develop Antlers and Ears*

Darken the shadow areas, using Burnt Sienna on the edge between light and shadow. Leave a few streaks to show texture. Paint the shadow area on the brow tine, as cast by one of the taller antler points.

Darken the ear edges with the ear colors from step 3. Try to keep the edge soft with feathery strokes. Use Burnt Sienna on the inside of the ear, indicating the hair pattern.

STEP 5: *Bring Life to Antlers and Ears*

Darken the curve of the antler tip as it comes out at the viewer using a thick layer of Burnt Umber and Ultramarine Blue. Add a wash of Ultramarine Blue and white, as the sky's reflection, to the top surface of the antler in the shadow areas. Add blue to the shadow side of each tine, to soften that edge. Add the little bony points and burrs that deer use to scrape trees near the antler base with Burnt Umber spots and streaks. Darken the patterns inside the ear with Burnt Umber and Burnt Sienna.

STEP 6: *Finish Antlers and Ears*

Add white spots and streaks to the antler points, indicating the sun striking the shiny bone. Also add white mixed with Raw and Burnt Sienna on the burrs around the antler base. Keep the darkest and lightest values on the closest antler tine; this makes it appear to sweep forward. Paint in the blue on the facing antler, where the sky is reflecting on the upper surface.

Finish the ears with white and Raw Sienna, indicating the final hair pattern, and add Ultramarine Blue in the shadows.

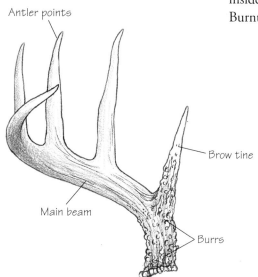

Antler points

Main beam

Brow tine

Burrs

Tips on Painting Antlers

Antlers can be tough to paint, especially in strong light. They vary a lot in color, depending on where the deer lives. Since antlers are polished bone, they reflect the colors around them. Have a lot of reference at hand!

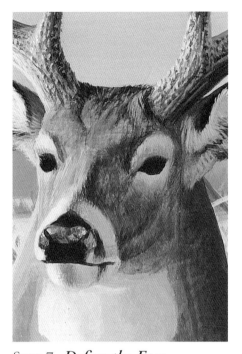

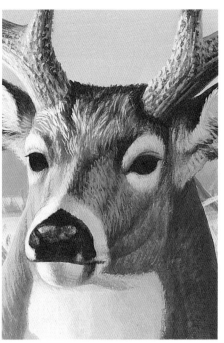

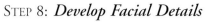

STEP 8: *Develop Facial Details*

Repaint the darkest areas of the nose and eyes with a mix of gray and Burnt Umber, redefining the dark pattern around the face. Indicate the upper eyelid with a thin brown line.

Darken the shadows with Burnt Umber washes, and enhance the neck muscle on the other side.

To indicate the hairs on the forehead, paint them in pure white, let that dry, and wash the white with Burnt Sienna.

Put some blue on the shadow side of the muzzle, as a sky reflection. Add warm yellow tones under the throat as a sun reflection.

STEP 7: *Define the Face*

Define some of the muscles and forehead patterns with Burnt Umber washes.

Redefine the pale hair around the eyes and nose, using a warm white for the sunny side and a mixture of Ultramarine Blue and a little Raw Sienna for the shady side.

Using brown tones, paint darker color around the eyeballs, where the eyelids will be.

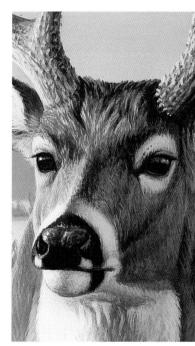

STEP 9: *Continue the Face*

Using a no. 2 round, paint a lower eyelid in a bluish gray, and put a touch of Burnt Umber within each eye, near the bottom, to indicate the liquid brown color of the deer's eye.

Add highlights to the eyes and nose, with blue on the right side and warmer browns and yellows on the left. Add some blue on top of the head.

STEP 10: *Add Final Face Details*

Add and refine highlights.

Use your no. 4 round to indicate hair patterns on the throat, using warm siennas and a little blue.

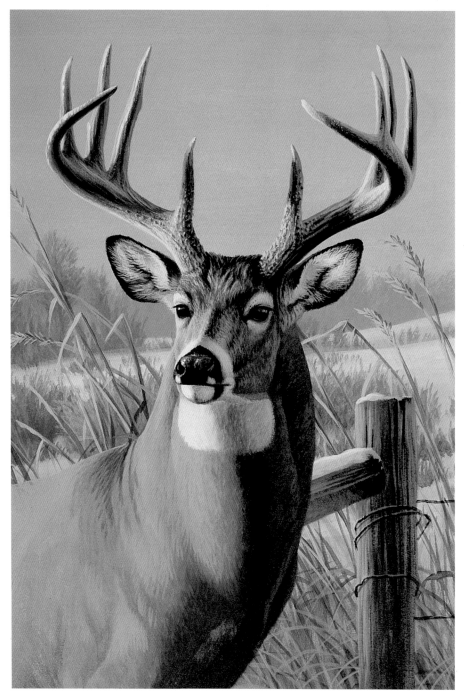

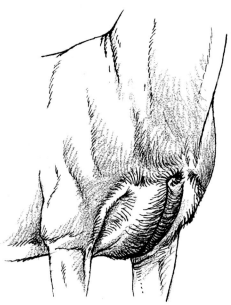

Do a study of the hair patterns on a deer's brisket; they can be complicated. Look at a few good deer mounts along with your photos. The brisket usually shows up pretty well on a taxidermy mount.

STEP 11: *Paint Neck and Shoulders*

Keep washing the sunlit areas of the neck with Raw Sienna, especially at the core of the shadow.

With a no. 3 flat, apply some bluish gray to the muscles on the right side, using short, scrubby strokes to indicate general hair direction.

Darken the shadow under the chin, keeping the warm value at the shadow core.

The neck should have a few folds as the deer turns his head.

Indicate some of the muscles and the major shoulder joint with Burnt Umber and sienna; this area is in shadow.

The brisket is one of the darkest areas on a deer; use a lot of umber and blue here.

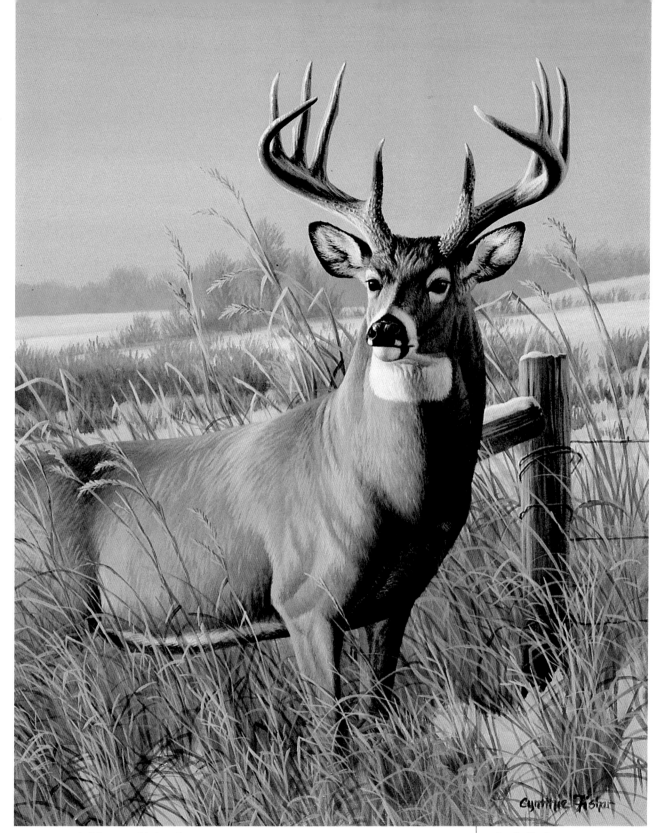

STEP 12: *Add Final Touches*

Using a no. 4 round and some white and Yellow Oxide, indicate hairs on the neck and shoulders, especially where the sun is hitting the muscles. Show some of the brisket hair patterns, as these are quite obvious on most deer. Wash the shadow core with strong browns and siennas, and paint a few darker hairs in this area. Finally, soften the right side of the neck with a blue/gray wash.

On the Lookout
Acrylic on hardboard
19" × 15" (48cm × 38cm)

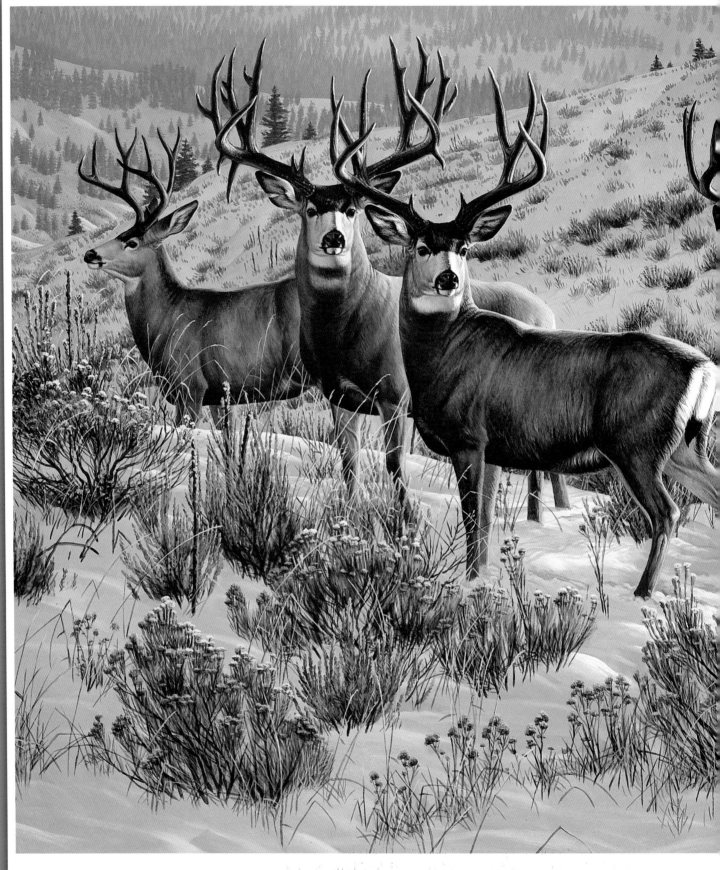

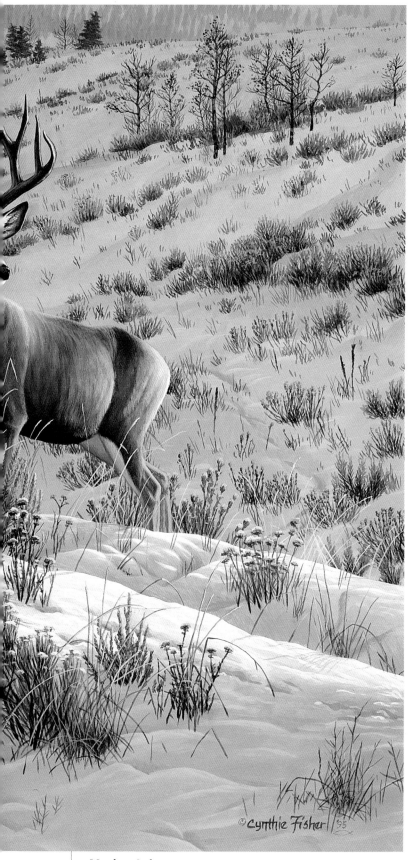

MULE DEER

Although mule deer share many of the same anatomical features with whitetails, there are quite a few differences which make these deer a lot of fun to draw and paint.

Mule deer are not as common and widespread as whitetails. Their habitat has defined many of their features. Their ears, markings, antlers, overall body shape and method of locomotion differ quite markedly from their whitetail cousins, and you will need to study these traits thoroughly to be able to successfully render a mulie. Mule deer tend to be less flighty than whitetails and can be quite approachable on their wintering grounds in western states, making sketching and photography a little easier. Gather your reference sources and do some detail studies of ears, eyes, nose, antlers and other features to familiarize yourself with the differences between this species and the white-tailed deer.

Members Only
Acrylic on hardboard
20" × 30" (51cm × 76cm)
Private collection

Starting With Ovals and Circles

Choosing a method to begin your sketches and paintings depends on how familiar you are with the subject. The more practice you get, the faster you will be able to block in the deer's basic form, adjusting it to fit any angle or perspective. Keep the four-legged structure in mind as you start working. Fill in the major blocks of the deer's front and hindquarters with rough shaping, and use quick, short strokes to indicate the facial features and legs.

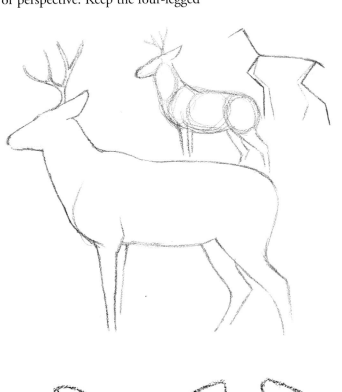

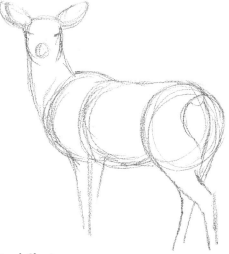

Rough Shaping
Look at your reference and get a feel for the overall shape of the deer's body, using circles, ovals and straight lines to get the basic outline down. Adding little touches like large ears and the rump patch will indicate that this is a mule deer. Try doing a lot of sketches like these from your reference, getting the "feel" for what makes mule deer different from whitetails.

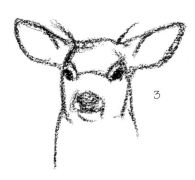

Basic Outline
Do a simple outline of a mule deer, roughing in the major features and adding more refinement as you progress. Those ears and forehead patch are very important in distinguishing this species.

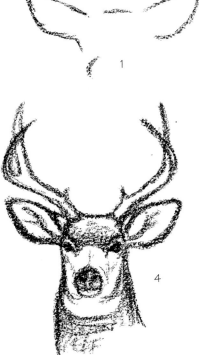

Seasonal Differences

All deer species change quite a bit in form and appearance with the onset of winter. Many of the finer anatomical features on the face and legs become more obscure as the deer grow thick winter coats, and the overall impression of size and weight increases with the longer fur.

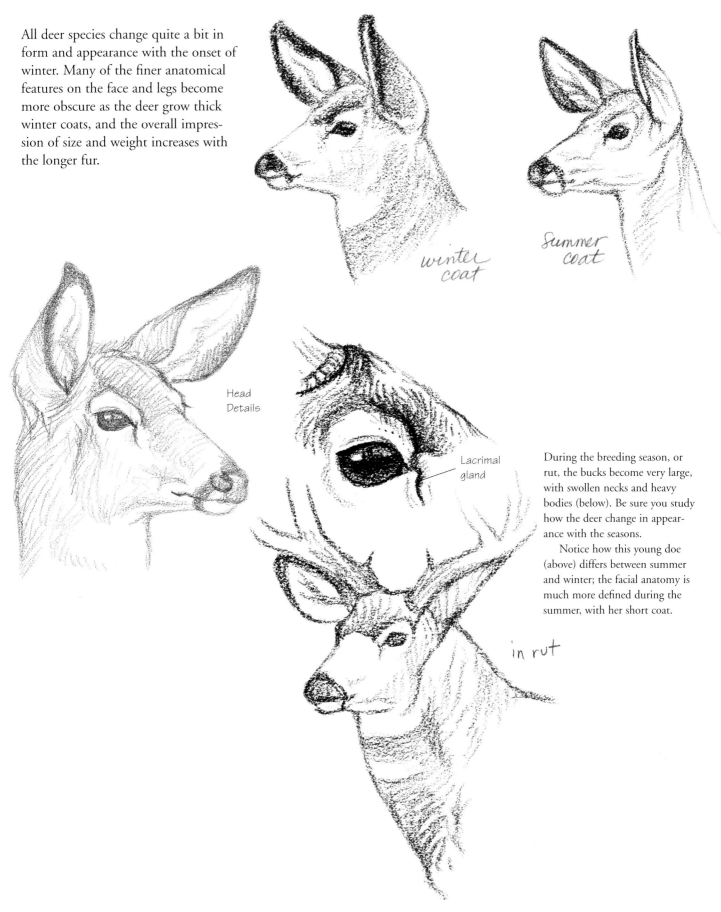

winter coat

summer coat

Head Details

Lacrimal gland

During the breeding season, or rut, the bucks become very large, with swollen necks and heavy bodies (below). Be sure you study how the deer change in appearance with the seasons.

Notice how this young doe (above) differs between summer and winter; the facial anatomy is much more defined during the summer, with her short coat.

in rut

The Buck

If you aspire to paint a large buck in his prime, standing in a regal pose, you will need to become familiar with the features that bring this image to life and differentiate between white-tails and mulies. Sketching the head and antlers of a typical mule deer buck will help you become more proficient in recognizing its characteristics.

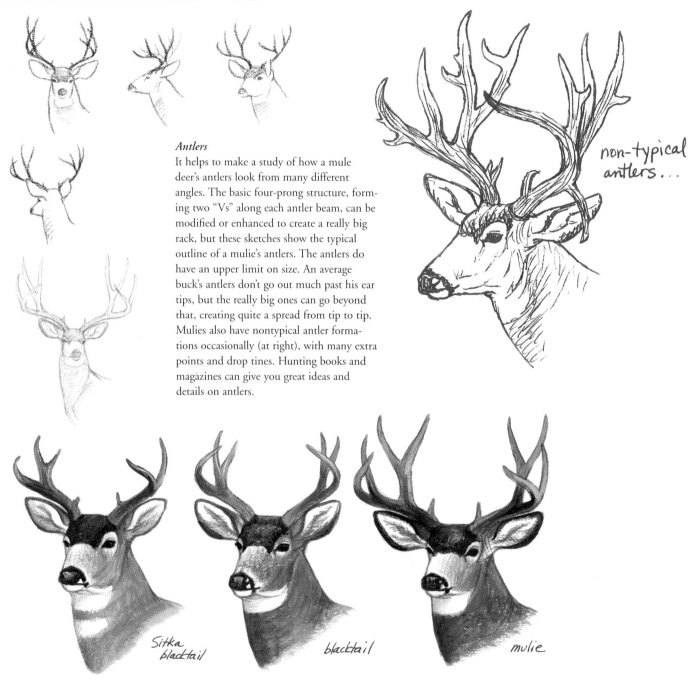

Antlers
It helps to make a study of how a mule deer's antlers look from many different angles. The basic four-prong structure, forming two "Vs" along each antler beam, can be modified or enhanced to create a really big rack, but these sketches show the typical outline of a mulie's antlers. The antlers do have an upper limit on size. An average buck's antlers don't go out much past his ear tips, but the really big ones can go beyond that, creating quite a spread from tip to tip. Mulies also have nontypical antler formations occasionally (at right), with many extra points and drop tines. Hunting books and magazines can give you great ideas and details on antlers.

non-typical antlers...

Sitka blacktail

blacktail

mulie

Mule Deer Types
There are several subspecies of mule deer, which differ slightly in coloration and markings as well as antler structure. The blacktail deer occurs along the Pacific coast from California up to Alaska, where it becomes the Sitka blacktail. Blacktails tend to have smaller, darker antlers, slightly smaller ears and browner coats, as well as a solid black tail. Western mule deer also differ from desert to mountain environments. Make sure you study these different types of mule deer so you correctly match the species with the habitat.

Action and Behavior

Doing studies of deer in action or engaging in typical daily behaviors can greatly enhance both your knowledge of how they live and move, as well as add interest to your paintings. Deer spend as much time resting as they can, but due to their flighty nature, they will often demonstrate many interesting poses and actions.

Along with noting the blockier body type of many mule deer, pay attention to the angle and pose of the head, as this will show the deer's level of alertness. Keep the hindquarters larger, as this is where they get their propulsive force.

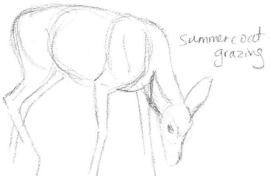

Summer coat grazing

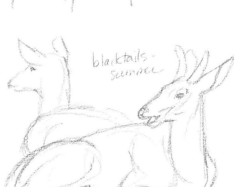

blacktails summer

Feeding and Resting

When a deer is feeding or resting, its muscle tone will be much less defined, and the attitude of its head, ears and neck will show a calmer demeanor.

In Motion

A spooked or running mule deer moves very differently than a white-tail. Because they tend to inhabit much steeper terrain, mulies have adopted a four-legged jump, much like the action of a pogo stick, to enable them to go rapidly up or down a mountainside. This "stotting" gait is quite spectacular as they spring up a hill, flaring their white rump patch. It also makes it easy for them to clear very tall obstacles!

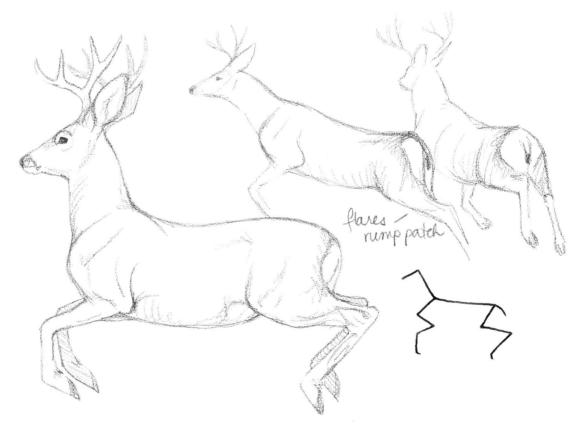

flares rump patch

Painting a Backlit Mule Deer

In this demonstration, the direction of the light will produce a dramatic result, creating a "halo" effect around the deer. Keep this backlighting in mind at all times, remembering to emphasize the areas where the sunlit and shady sides meet with the brightest color.

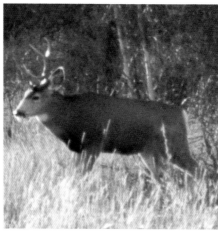

Reference Photo
In this photo the colors and light direction are easy to ascertain, and when combined with other reference sources, will help generate a nice painting.

MATERIALS

Surface
Gessoed hardboard panel, stone gray

Paints
Burnt Umber
Burnt Sienna
Raw Sienna
Raw Umber
Yellow Oxide
Ultramarine Blue
Phthalo Blue
Payne's Gray
Titanium White
Deep Violet

Brushes
Round: no. 2, no. 6
Flat: no. 8, ½-inch (12mm)

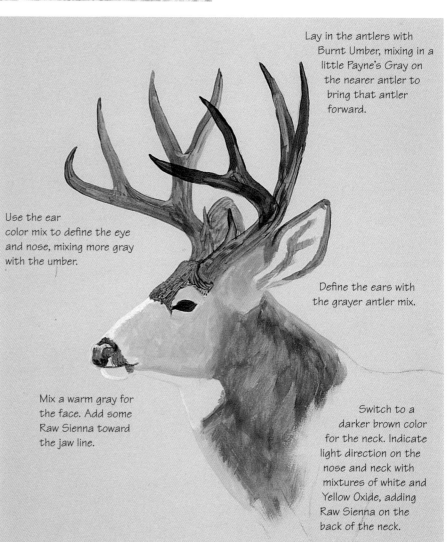

Lay in the antlers with Burnt Umber, mixing in a little Payne's Gray on the nearer antler to bring that antler forward.

Use the ear color mix to define the eye and nose, mixing more gray with the umber.

Define the ears with the grayer antler mix.

Mix a warm gray for the face. Add some Raw Sienna toward the jaw line.

Switch to a darker brown color for the neck. Indicate light direction on the nose and neck with mixtures of white and Yellow Oxide, adding Raw Sienna on the back of the neck.

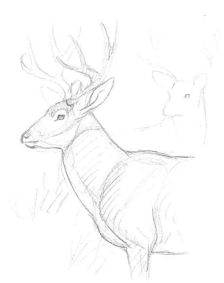

STEP 1: *The Initial Sketch*

Draw your sketch to size using large ovals and circles to help build the deer, and transfer it to your board.

STEP 2: *Begin the Wash*

Define the outline of the deer's face, neck and antlers, using fairly strong colors and short brushstrokes. Use a no. 6 round for the antlers, ears, eye and nose and a no. 8 flat for the body and neck.

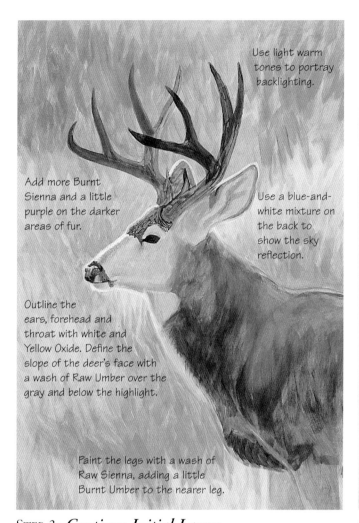

Add more Burnt Sienna and a little purple on the darker areas of fur.

Use light warm tones to portray backlighting.

Use a blue-and-white mixture on the back to show the sky reflection.

Outline the ears, forehead and throat with white and Yellow Oxide. Define the slope of the deer's face with a wash of Raw Umber over the gray and below the highlight.

Paint the legs with a wash of Raw Sienna, adding a little Burnt Umber to the nearer leg.

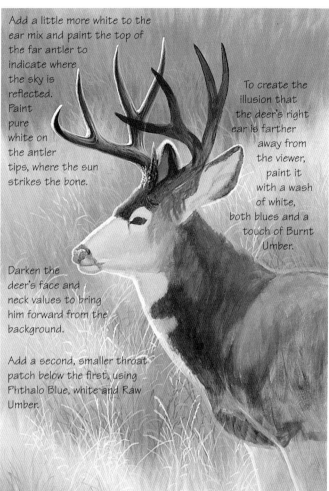

Add a little more white to the ear mix and paint the top of the far antler to indicate where the sky is reflected. Paint pure white on the antler tips, where the sun strikes the bone.

To create the illusion that the deer's right ear is farther away from the viewer, paint it with a wash of white, both blues and a touch of Burnt Umber.

Darken the deer's face and neck values to bring him forward from the background.

Add a second, smaller throat patch below the first, using Phthalo Blue, white and Raw Umber.

STEP 3: *Continue Initial Layers*

Lay in the initial washes on the rest of the deer with your no. 8 flat.

STEP 4: *Reinforce the Deer*

Use your no. 6 round to paint in the face and your no. 8 flat to continue work on the body.

NEAR ANTLER

Keep the nearest antler darker, using Raw and Burnt Umber washes. Paint a white outline on the sunlit side of the antler, then wash it with Raw and Burnt Sienna. Delineate veins and ridges on this antler with the blue/gray mix from step 4.

NEAR EAR

Finish the ear by darkening the inner ear patterns with Burnt Umber and Payne's Gray and then painting the lighter hair areas with a bluish gray. Enhance the wrinkles at the ear base with Burnt Umber in the "cracks" of the fur, adding Raw Sienna mixed with white between these cracks. Add the "halo" of light around the ear edge by painting a pure white line around the ear and then washing most of it with Raw and Burnt Sienna, keeping this line soft.

FACE AND NECK

Define the face and neck with washes of Raw Umber and Ultramarine Blue mixed with Burnt Umber and a little white. Define the dark muzzle and forehead pattern with Burnt Umber and Payne's Gray using short, delicate strokes.

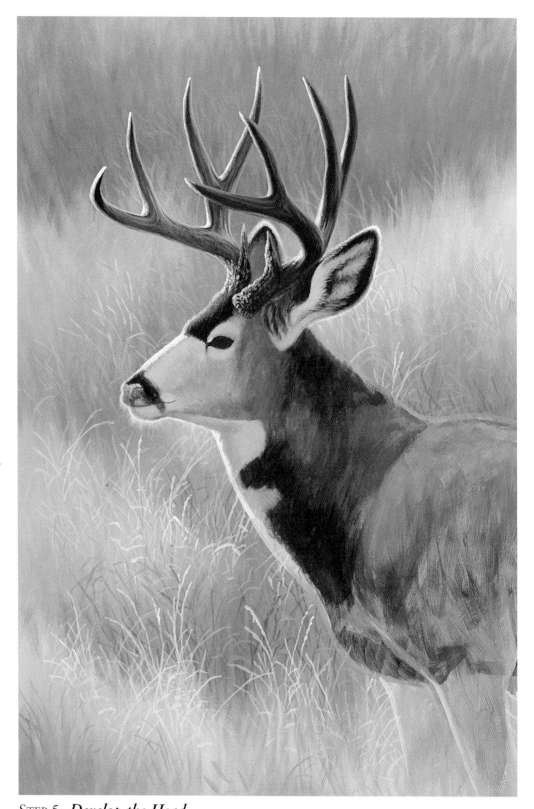

STEP 5: *Develop the Head*

Keep the contrast high between the forehead and face. Pay attention to hair patterns within the ear.

FACE DETAILS

Add your darkest areas with Payne's Gray on the eye, nose and forehead; they are the center of interest. Use blue and some warm tones taken from the background to highlight the upper half of his eye using your no. 2 round. Emphasize facial muscles in the jaw area with light strokes of Raw Umber.

BACKLIGHTING

Reapply the soft white edge all around the face and neck, then wash the white with either Raw Sienna or Burnt Sienna, depending on the color of the hair underneath; white areas should have a lighter, more yellow highlight. Keep your edges soft using dry-brush and scrubbing strokes to blur the edges around the buck's head.

WHISKERS

Indicate backlit whiskers under the deer's chin using white with a touch of Yellow Oxide and dry-brush strokes.

SHADOWING

Add Burnt Umber on the underside of the deer's neck, next to the highlight, to enhance that feeling of roundness.

NECK AND SHOULDER

Continue to increase value down the neck and shoulder with Burnt Umber.

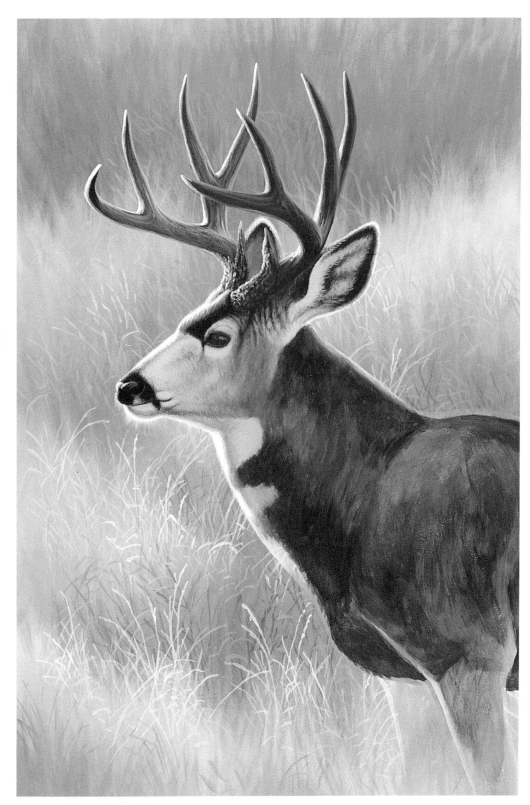

STEP 6: *Finish the Face, Develop the Body*

Enhance the buck's expression by adding details around the eyes, nose and mouth.

BODY

Intensify color on the body by applying more of the colors used for the neck and dark fur from steps 2 and 3.

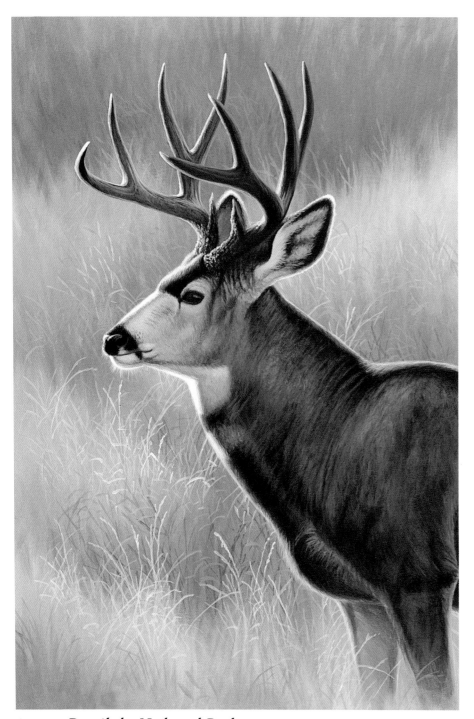

STEP 7: *Detail the Neck and Back*

Painting mule deer hair is tough; it has a speckled, undefined quality, and doesn't look accurate painted with a hair-by-hair approach.

Keep the edge of the neck and back near the backlit highlights the darkest, and alternate from light to dark, using your flat brush to indicate the subtle hair patterns which tend to create faint "stripes" and wrinkles around the neck. Try stippling with a fairly dry brush to indicate the salt and pepper look of mule deer hair. Use a mixture of Ultramarine Blue, white and some Burnt Umber on the top of the neck and shoulder area, and less white for the lower half of the neck and darker fur areas. Keep lots of reference handy!

Indicate a few individual hairs in the brisket area with your no. 6 round and a white/Burnt Umber mix.

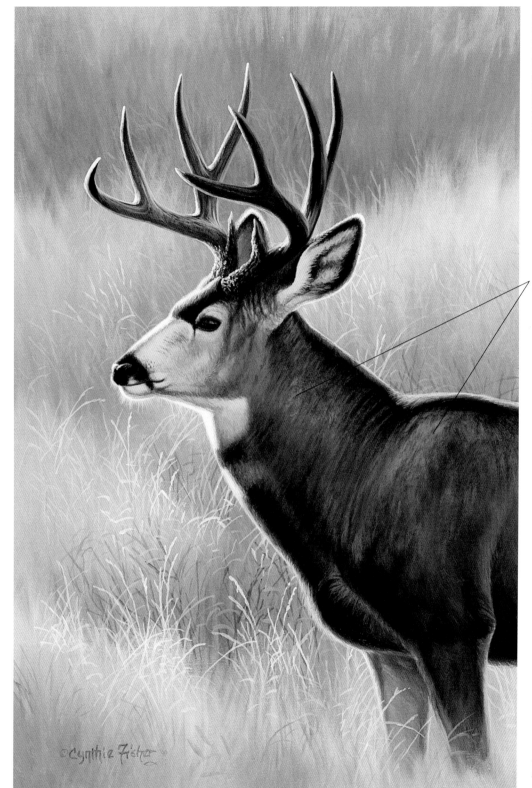

Background

A subtle background of sunlit and shadowed grasses really pops the deer into the foreground. The individual blades of grass help set him into his habitat.

Stipple with a flat brush

Fat and Sassy
Acrylic on hardboard
16" × 10½" (41cm × 27cm)

STEP 8: *Add Final Touches*

Continue your hair pattern throughout the rest of the deer.

A buck in rut is usually in such sleek condition that you won't need to define too many muscles, as they are hidden by the thick hide and coat. But keep the underlying structure in mind, the points of the shoulder and elbow. Define a few muscles in the upper foreleg nearest the viewer, with the blue/white/brown mix used to highlight the shoulder blade in step 7.

Since the deer is fairly dark, the colors will deepen once the painting is varnished.

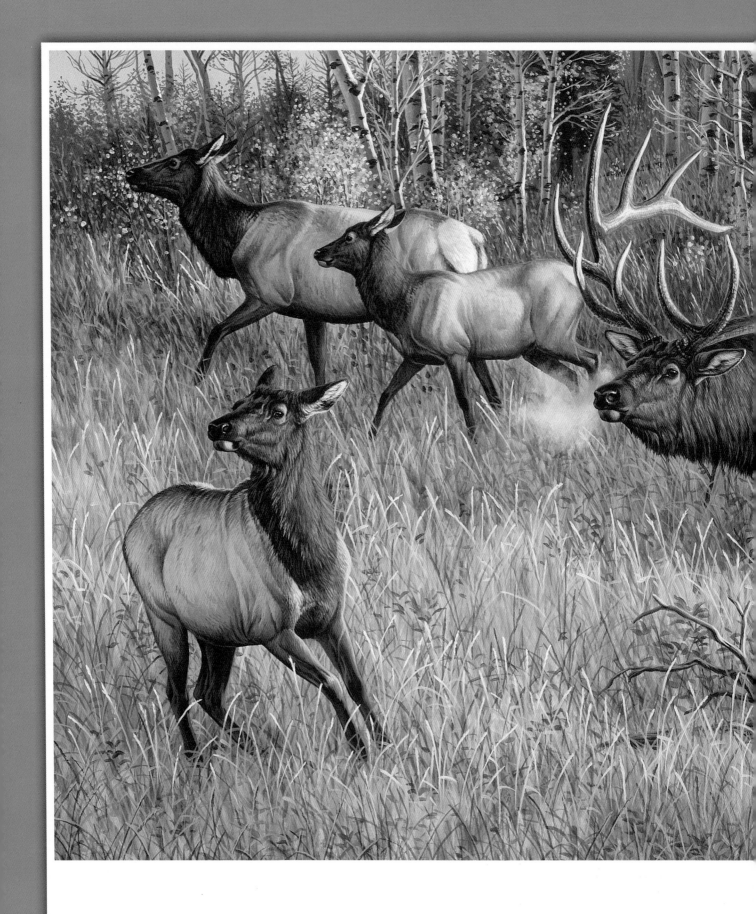

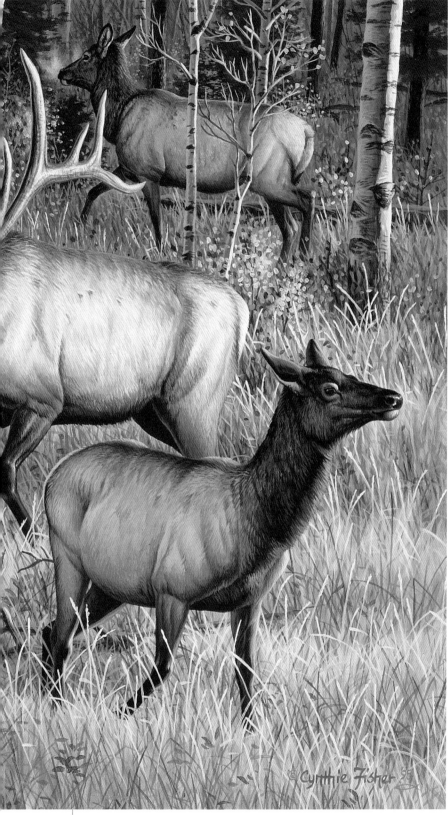

September Song
Acrylic on hardboard
20" × 30" (51cm × 76cm)
Private collection

4

ELK

Elk are a pleasure to sketch and paint, with their bold coloration, defined muscle tone and those impressive antlers. Add to that their choice of beautiful mountain habitats and interesting social structure, and there are endless possibilities when painting elk.

Luckily, there are also endless sources of reference, and elk are fairly easy to get close to in certain areas. Many national parks and refuges in western North America boast healthy elk populations, and if you visit during the fall rutting season, you are virtually guaranteed a good show!

Because of their complicated antlers, more visible anatomy and a wide variety of poses and behaviors, elk can be a challenge to render accurately. They are much larger than deer, and their herding and mating behaviors can add a lot of interest and drama to any painting.

A Species Study

Immerse yourself in your subject and learn as much as you can about the animal. These sketches pave the way to learning how to sketch an elk without necessarily having the perfect photo for reference. There's nothing like hands-on study when you're learning something new! Don't be concerned if your animals look a little awkward at first; you will get better with practice.

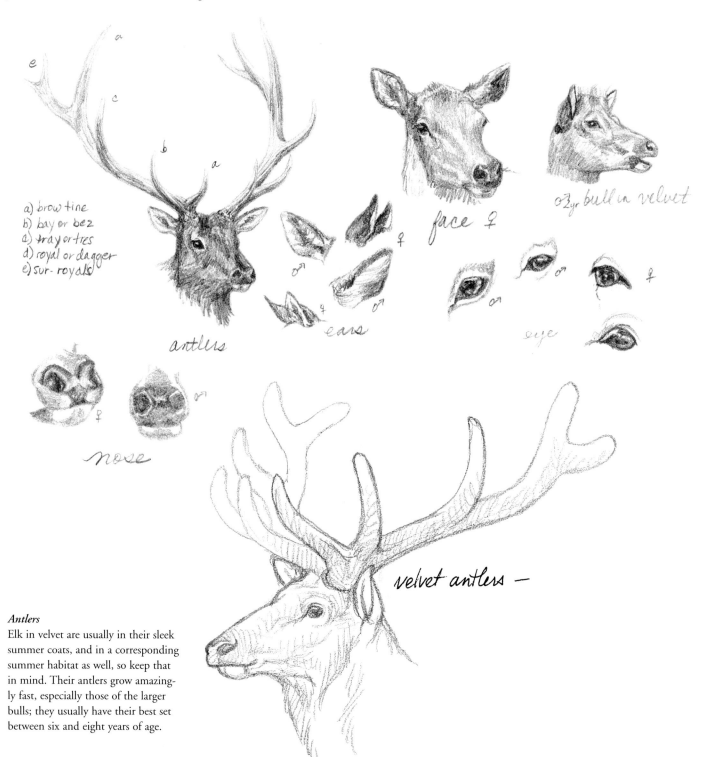

a) brow tine
b) bay or bez
c) tray or tres
d) royal or dagger
e) sur-royals

antlers

ears

face ♀

3yr bull in velvet

eye

nose

velvet antlers —

Antlers
Elk in velvet are usually in their sleek summer coats, and in a corresponding summer habitat as well, so keep that in mind. Their antlers grow amazingly fast, especially those of the larger bulls; they usually have their best set between six and eight years of age.

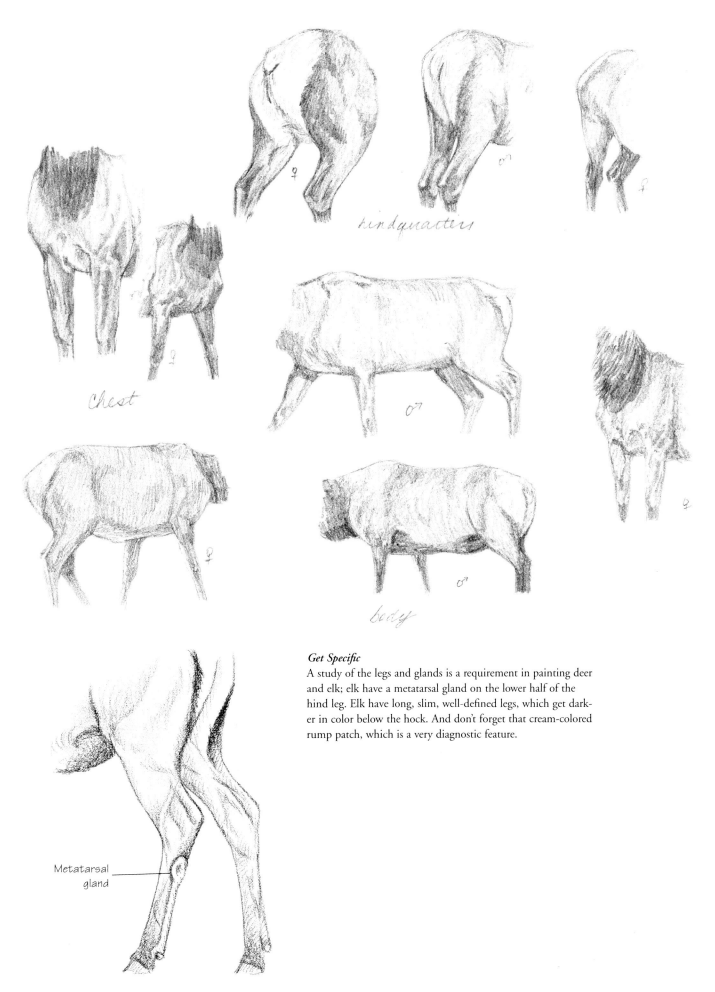

hindquarters

chest

body

Get Specific

A study of the legs and glands is a requirement in painting deer and elk; elk have a metatarsal gland on the lower half of the hind leg. Elk have long, slim, well-defined legs, which get darker in color below the hock. And don't forget that cream-colored rump patch, which is a very diagnostic feature.

Metatarsal gland

Painting Long Elk Fur

With this smaller study painting we'll focus on creating texture and accurately portraying facial anatomy and hair patterns, using a diffuse source of light and keeping the colors bright and details sharp. Elk have longer, more defined hair than deer, especially on the neck and forehead, and you can use these techniques for many other longer-haired species.

You need to remember that you haven't painted every hair, although it might look as though you did. The initial washes are critical in creating the illusion of lots of detail, and because they are laid down with fairly undiluted pigment, they are the brightest colors and add the most punch to your painting.

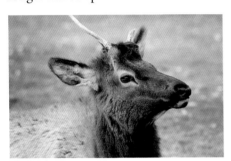

Reference Photo
Although this spike bull elk isn't big and impressive, he presents a good study of facial muscles and hair structure and patterns, as well as how the eye and nose look on an overcast day.

MATERIALS

Surface
Gessoed hardboard
panel

Paints
Burnt Umber
Burnt Sienna
Raw Umber
Raw Sienna
Yellow Oxide
Ultramarine Blue
Alizarin Crimson
Payne's Gray
Titanium White

Brushes
Round: no. 4
Flat: no. 2

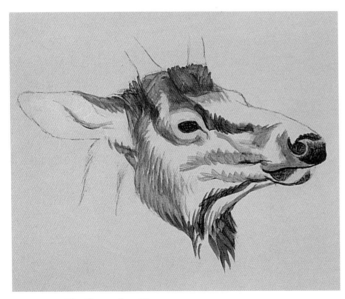

STEP 1: *Define the Form*

After sketching in your elk form, use your no. 4 round to follow the hair patterns with short, easy brushstrokes. Use a mixture of Burnt Umber and Ultramarine Blue for the darker regions and Raw Umber for less-defined areas. Fill in the eye and nose areas with the darker mixture; you will detail these later.

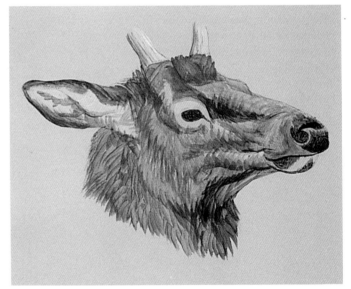

STEP 2: *Fill in With Color*

Continue to use your brushstrokes to define the hair patterns, using thinned but pure pigments. Use your flat brush to wash Raw and Burnt Sienna into the brightest areas, like in the ear, around the eye and on the back of the head. Use a thin wash of blue, crimson and white on the top of the head as a reflection from the sky.

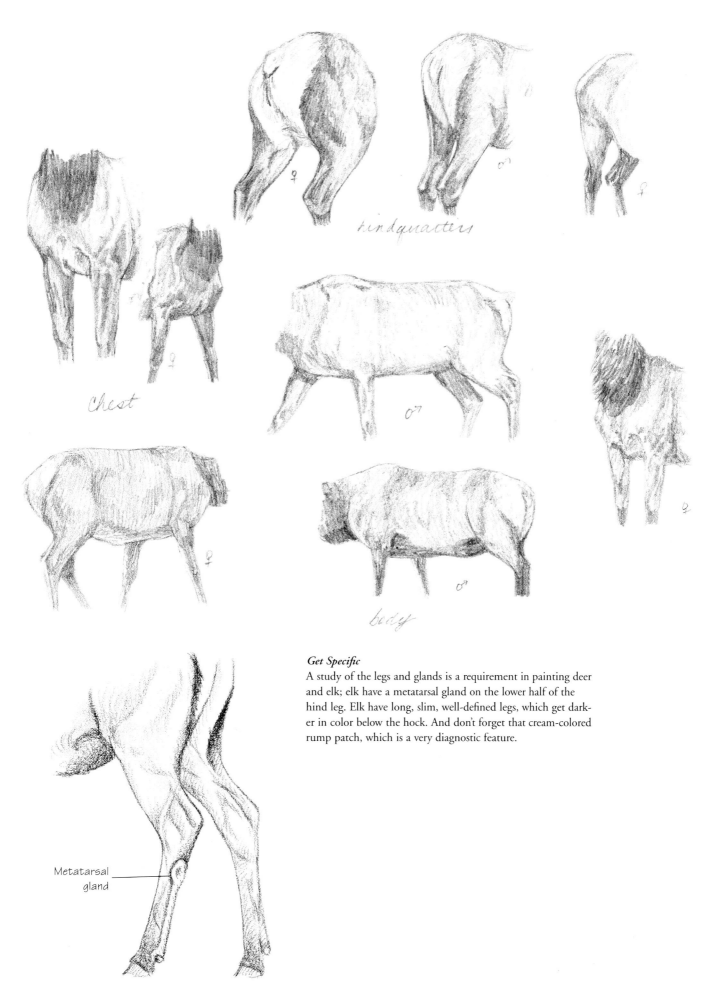

hindquarters

chest

body

Get Specific

A study of the legs and glands is a requirement in painting deer and elk; elk have a metatarsal gland on the lower half of the hind leg. Elk have long, slim, well-defined legs, which get darker in color below the hock. And don't forget that cream-colored rump patch, which is a very diagnostic feature.

Metatarsal gland

Defining Form

Using a few lines to define the borders, try outlining the basic shape of an elk, remembering that it is heavier and taller than a deer, with a longer face and more defined muscle tone. Use some lines indicating the joints or lay in some rough circles to fill in the form. It's easy to get carried away with antler size, so try to concentrate on body structure first, then add the antlers, and define the body mass.

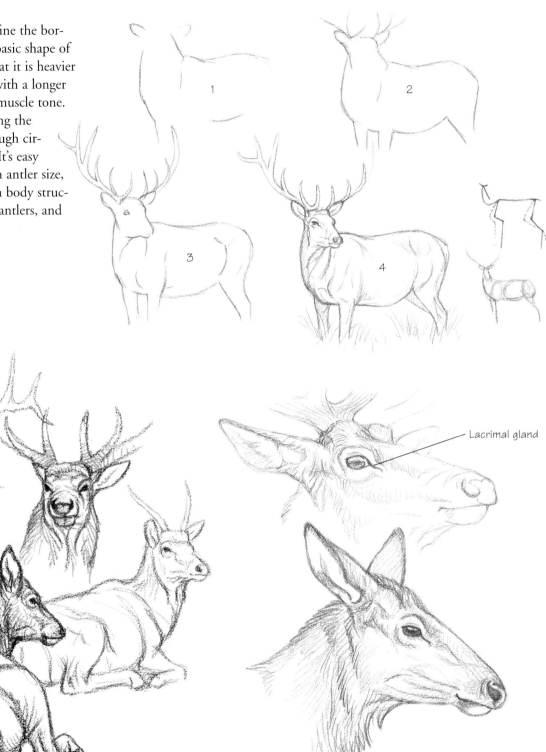

Lacrimal gland

Angles
After you've gathered some reference, pick some of the more challenging angles and see if you can draw them convincingly. Practicing this way will make it much easier to create a pose that you can't find in your reference.

Head Study
The shorter hair on the face makes the muscles and bony structures more apparent. Elk have a lacrimal gland at the eye corner too. This gland is most obvious in a bugling bull, when the slit will open and create a small pit next to the eye.

Action and Behavior

When drawing elk in action, familiarize yourself with their muscle structure, as it shows distinctly through their sleek coats. Pay attention to the carriage of the head and ears, as this relates the animal's state of mind and intentions. An elk moves a bit like a horse, since it is built larger and lankier than the smaller deer; it trots and gallops like a horse, but an elk can leap enormous obstacles.

Bull Expressions
A bull elk bugles during the mating season, or rut, giving out a deep roar that becomes a high-pitched scream when he is advertising his presence. This differs from the "flehmen" expression, which the bull uses when testing an odor. Sometimes artists paint what they believe is a bugling bull when the bull is actually performing a flehmen gesture instead. You will notice that almost all deer, elk and antelope use this strange, lip-curling posture when testing a scent.

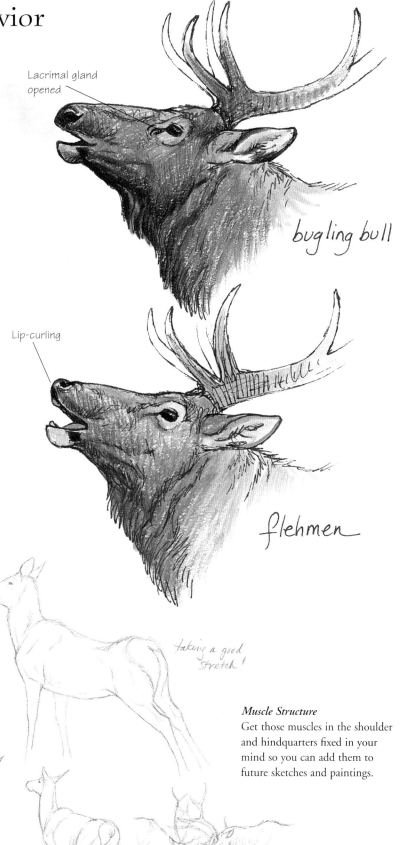

Lacrimal gland opened

bugling bull

Lip-curling

flehmen

taking a good stretch!

Muscle Structure
Get those muscles in the shoulder and hindquarters fixed in your mind so you can add them to future sketches and paintings.

Painting Long Elk Fur

With this smaller study painting we'll focus on creating texture and accurately portraying facial anatomy and hair patterns, using a diffuse source of light and keeping the colors bright and details sharp. Elk have longer, more defined hair than deer, especially on the neck and forehead, and you can use these techniques for many other longer-haired species.

You need to remember that you haven't painted every hair, although it might look as though you did. The initial washes are critical in creating the illusion of lots of detail, and because they are laid down with fairly undiluted pigment, they are the brightest colors and add the most punch to your painting.

Reference Photo
Although this spike bull elk isn't big and impressive, he presents a good study of facial muscles and hair structure and patterns, as well as how the eye and nose look on an overcast day.

MATERIALS

Surface
Gessoed hardboard panel

Paints
Burnt Umber
Burnt Sienna
Raw Umber
Raw Sienna
Yellow Oxide
Ultramarine Blue
Alizarin Crimson
Payne's Gray
Titanium White

Brushes
Round: no. 4
Flat: no. 2

STEP 1: *Define the Form*

After sketching in your elk form, use your no. 4 round to follow the hair patterns with short, easy brushstrokes. Use a mixture of Burnt Umber and Ultramarine Blue for the darker regions and Raw Umber for less-defined areas. Fill in the eye and nose areas with the darker mixture; you will detail these later.

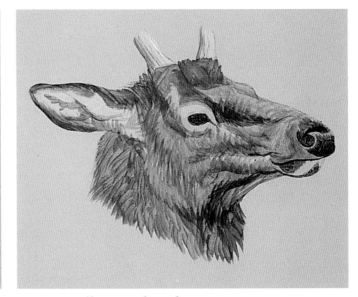

STEP 2: *Fill in With Color*

Continue to use your brushstrokes to define the hair patterns, using thinned but pure pigments. Use your flat brush to wash Raw and Burnt Sienna into the brightest areas, like in the ear, around the eye and on the back of the head. Use a thin wash of blue, crimson and white on the top of the head as a reflection from the sky.

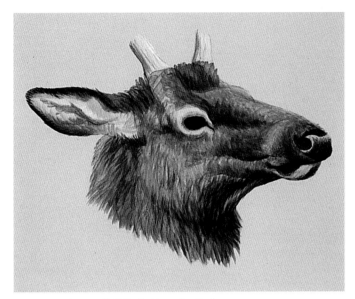

STEP 3: *Detail With Dark Colors*

With a mix of Burnt Umber and Payne's Gray, fill in the nose, eye and other dark areas with the round brush.

Indicate some of the deeper areas of fur on the neck and head, painting this mixture between the clumps, letting the original wash show through.

Define a few of the facial muscles with short brushstrokes and your dark mix.

STEP 4: *Establish Dark Value*

Continue to add details with the darker mix, using long strokes where the hair is long and shorter strokes on the muzzle and around the mouth and eye. A few strategic brushstrokes imply how the rest of the coat is textured.

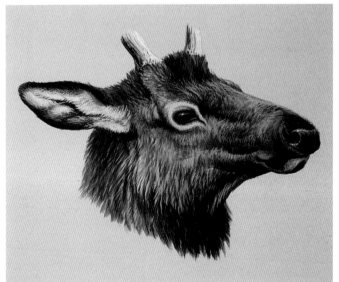

STEP 5: *Add Light Colors*

Using the round brush, paint a warm mixture of Raw Sienna, Yellow Oxide and white around the eye, the chin and within the ear, indicating the hair directions. Paint a few strokes between some of the deeper "cracks" in the fur, but not so many that you lose your earlier tones. If you end up with too much light hair, wash over it with a pure pigment, such as Raw Umber or sienna. Paint a thin blue/gray mix for a lower eyelid.

STEP 6: *Add Final Touches*

Add eye highlights with a dark blue/gray mix to indicate a bright but partly overcast day.

Use umber and blue to texture and highlight the nose, then wash on a few highlights with a blue, umber and white mix. Add a little crimson to indicate the sky's reflection off the bull's nose and forehead.

Painting Elk Antlers

Here we'll paint an elk's left antler as it would look on a sunny afternoon, with rich colors and direct lighting. Painting antlers for all deer species is basically the same, since they share similar textures; the differences lie in your source of light and the basic structure of the antler tines and main beam, as each species is unique in its antler conformation.

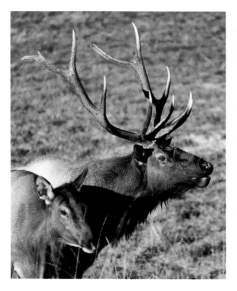

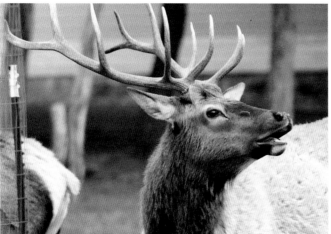

Reference Photos
These photos show elk antlers in different lighting situations; the bull at left is similar to the one used in this demonstration. Antler color varies tremendously, depending on where the elk lives and what he uses to rub his velvet off, as certain trees and bushes can impart a color.

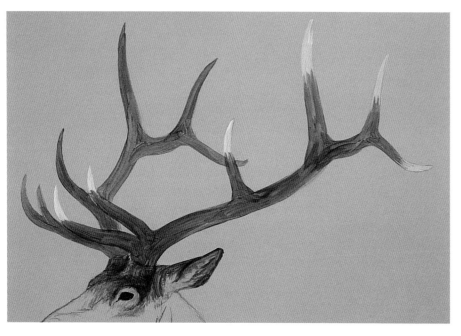

STEP 1: *Start With Warm Tones*

After studying and sketching elk antlers, and getting the feel for a "typical" six-point antler, transfer your antler drawing to your gessoed hardboard panel. Use a warm Burnt Umber and Raw Sienna mixture to lay in the initial wash, using white on the antler tips. Use broad, sweeping strokes with your no. 6 round, trying to follow the pattern of veining in the antler.

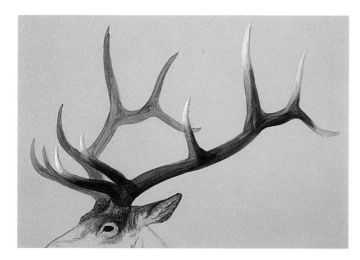

STEP 2: *Add Dimension*

Use more Burnt Umber to darken the shaded side of each tine, also showing where the shadow from the tine falls on the antler beam. Check your reference, or better yet, have an actual antler to look at. Use a little Phthalo Blue in the shadow on the white antler tips. Use some white and Yellow Oxide to blend the area where the white and umber meet on each tine. Continue with a no. 6 round to use your brushstrokes to create the texture on the antler, following the main beam up along its length.

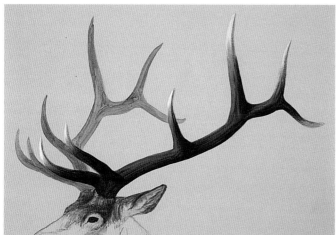

STEP 3: *Finish the Darks*

Wash the antler again with Raw Sienna, Burnt Sienna and some Burnt Umber. Use umber with some Payne's Gray to really indicate those shadows and the antler texture, including a few bumps around the antler base. Touch up the shadows on the antler tips with a little Raw Umber using your no. 4 round.

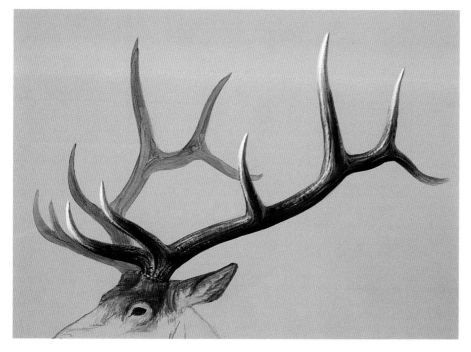

STEP 4: *Add the Lights*

To finish, use thick white on the antler tips, then mix in some Yellow Oxide and continue the highlights down each tine onto the main antler bcam, washing some of it with Raw and Burnt Sienna. Follow a few of the darker lines you created earlier with this highlight mixture, to make these "veins" stand out. Use some Phthalo Blue and white on the shaded side of the antler, also indicating the rough, bumpy texture with your brushstrokes. Add some blue and white light accents to the burrs around the antler base with your no. 4 round.

5

MOOSE, CARIBOU, SHEEP *and* ANTELOPE

This chapter focuses on the incredible variety found within the family of hooved animals; we'll only touch on a few, but you'll notice many similarities found in all types of big game. Moose and caribou are both built to withstand the rigors of the harsh northern hemisphere, while the antelope's body is matched to its wide-open habitat, and wild sheep exhibit a stocky, sturdy shape that echoes the crags and cliffs they call home. Each species is remarkably adapted to where it lives, and each one possesses incredible beauty, original behaviors, and special adaptations that inspire artists every day.

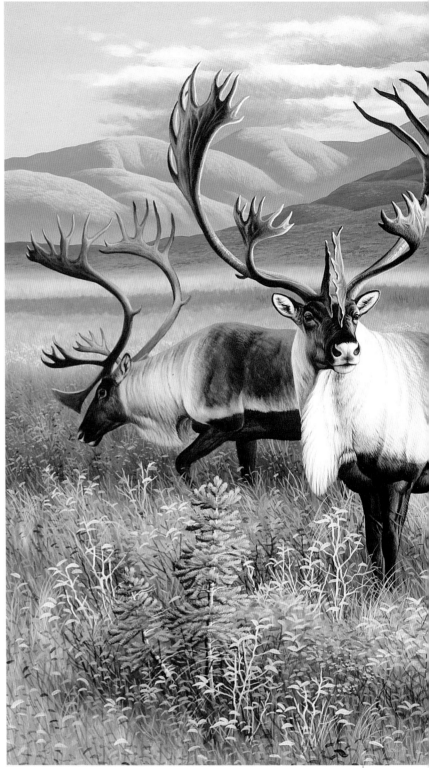

Northern Nomads
Acrylic on hardboard
20" × 30" (51cm × 76cm)
Private collection

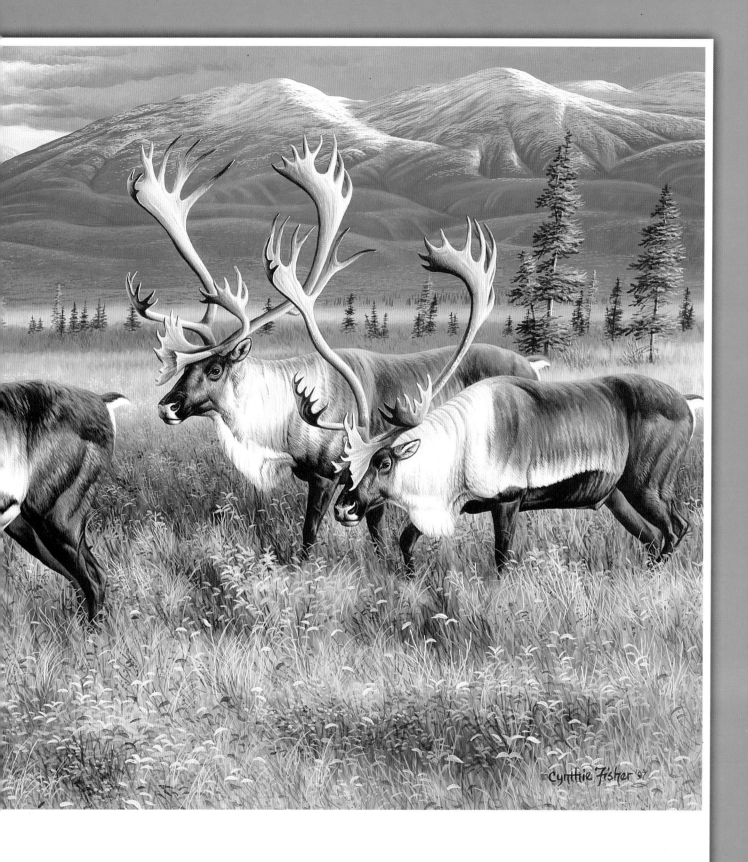

Sketching Moose

Moose present a challenge with their unique physical characteristics. Of course those long legs make them extremely tall, but they also have a relatively short back and an impressive hump at the shoulder. The face and antlers are unusual among the deer family and require special study. In doing quick sketches and studies, emphasize the nose profile, shoulder height and narrow hindquarters.

Gather as much reference as possible. It will help to find a mounted specimen to study for antler configuration and facial anatomy.

Moose are very colorful in the fall, with their two-toned, shiny coats and pale legs. The light-colored antlers on the bulls stand out from a long distance, contrasting with their dark bodies.

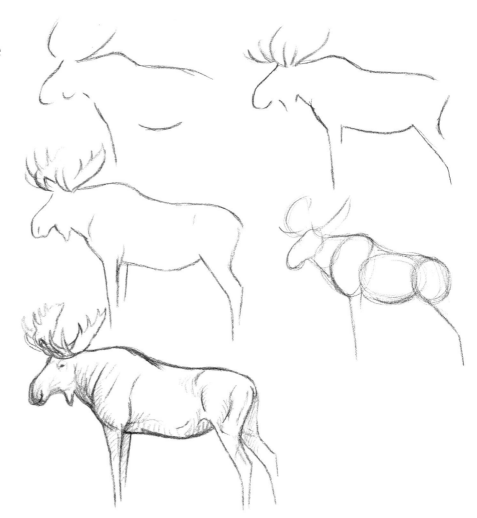

Capturing the Moose Shape
Keeping in mind those singular characteristics of a long nose and tall shoulders, start with a few strokes to get the feel of the outline. Complete the body, remembering the narrow hindquarters and sloping back, as well as the bell under the chin and the paddle shape of the antlers. It's amazing how just a few lines can immediately identify the species you are drawing! Try using circles to indicate larger masses.

Practice All Angles
Because moose are built so differently, practice a few odd angles, noticing the relatively wide chest and the straighter angles in the hind legs; moose carry a lot of their mass and bulk in their front end.

Anatomical and Seasonal Differences in Moose

Because moose spend their time in many types of habitats and experience severe temperature extremes, their physical structure is very well suited to enable them to survive in marginal habitats, such as tundra thickets, swamps, thick forests and deep snow. Their large size helps them retain heat in the winter, and they move easily through the snow on long, powerful legs.

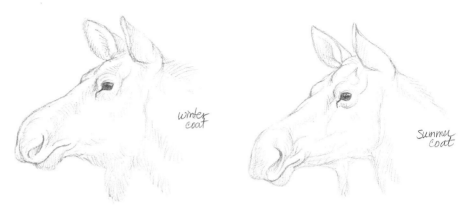

Winter and Summer Coats
Moose almost look normal in their very dense winter fur, which hides a lot of their facial structure. Once they grow their sleek summer coat, their faces look even longer, and the bulbous nasal area is very apparent.

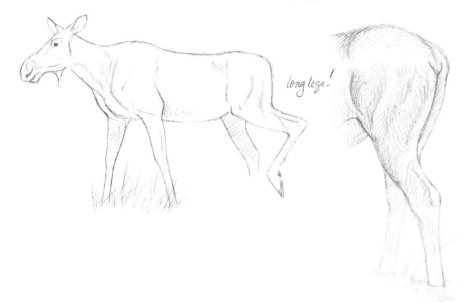

Legs
It's hard to make a moose's legs too long! Usually you won't see the whole leg, since most moose spend their time in marshes or tall grass. Notice the slope and narrow appearance of their hindquarters. There's usually a fairly strong color difference as well, with lighter grizzled hairs on top, a sleek almost black coat in the middle and pale, nearly white legs beneath.

Antlers
Moose antlers are quite variable and are very tricky to reproduce. The basic structure has a large paddle shape on either side, often spanning six feet (1.8 meters), and a smaller, tilted hand-shaped paddle closer to the face. In younger bulls this second paddle may be missing or be represented by a few odd points. There are many points sprouting from the outer edge of the large paddle, which the bulls can use to engage their antlers when fighting.

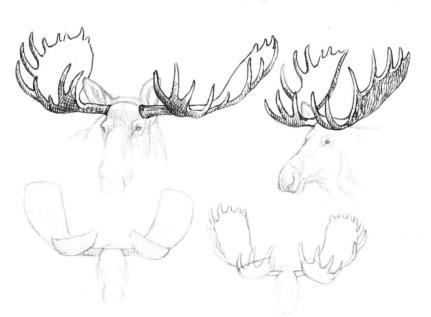

Painting a Bull Moose

This demonstration focuses on the fun colors and textures a big Alaskan bull moose displays on the tundra in the fall, with strong afternoon light. Moose can have very rich coloration in autumn, with nice purple highlights on their glossy dark coats.

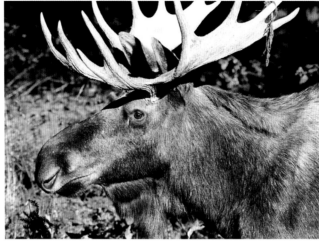

Reference Photo
This is a Shiras moose from Wyoming. The differences between types of moose are subtle but important for accuracy.

MATERIALS

Surface
Gessoed hardboard panel, stone gray

Paints
Burnt Umber
Raw Umber
Burnt Sienna
Raw Sienna
Payne's Gray
Ultramarine Blue
Phthalo Blue
Phthalo Green
Yellow Oxide
Alizarin Crimson
Titanium White

Brushes
Round: no. 6
Flat: no. 4

ANTLERS
Lay in the antlers with your round brush, using Raw Sienna and Raw Umber on the darker areas and some Yellow Oxide and white where the sun hits the paddle of the antler. Paint shadow areas with a mixture of Phthalo Blue and Burnt Umber.

FACE/BODY MUSCLES
Paint the facial and body structures using your flat brush and a mixture of Burnt Umber, Ultramarine Blue and a little Alizarin Crimson. Follow the major muscle groups, and remember the light direction, which comes from the right.

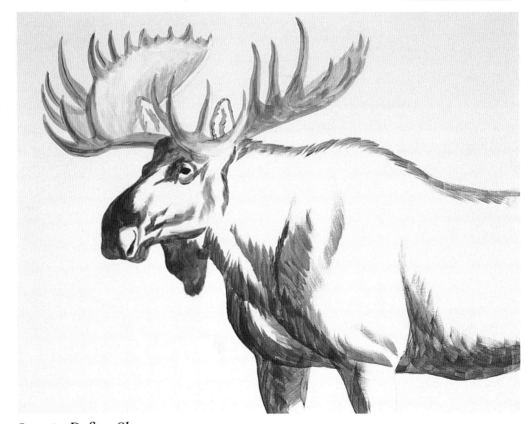

STEP 1: *Define Shapes*
Create your initial sketch and transfer it to your painting surface.

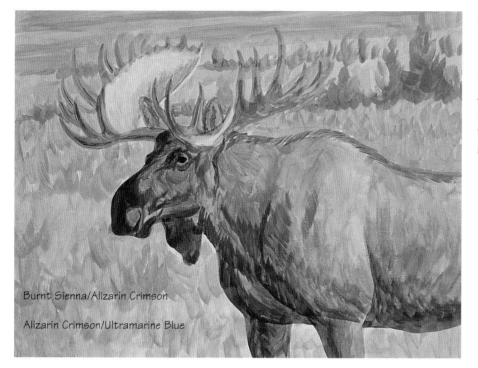

Burnt Sienna/Alizarin Crimson

Alizarin Crimson/Ultramarine Blue

STEP 2: *Finish Laying In Colors*

Use a lot of Raw Sienna and a little Burnt Umber on the bull's body and face. Blend in some Burnt Sienna and Alizarin Crimson on the bull's lower half with your flat brush, and finish with a purple mixed from crimson and Ultramarine Blue.

RIGHT ANTLER

Use your round brush to wash the antler with Raw Sienna, adding Burnt Sienna as you paint closer to the antler tines. Use white and streaks of Burnt Umber to indicate the antler texture on the antler paddle, washing the white with Raw Sienna if it gets too bright (keep the tips fairly white). Use Burnt Umber and Ultramarine Blue on the shaded side of each tine.

HEAD AND NECK

Add reflected light beneath the antler with a white/Ultramarine Blue mix. Wash the head and neck with Raw Sienna and Burnt Umber. Add crimson near the bottom jaw line.

DARK HAIR

Add hair details along the muscle lines with Burnt Umber and Raw Sienna. Use Burnt Umber and Payne's Gray on the moose's nose, eye, forehead and beneath the neck to show the darkest areas of hair.

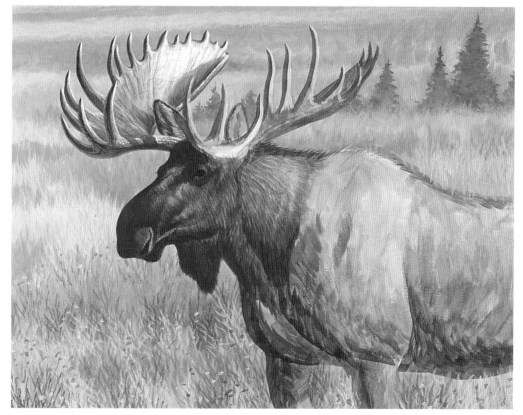

STEP 3: *Paint the Right Antler, Head and Neck*

Continue defining the antler, face and neck with darker values, keeping anatomy in mind.

LEFT ANTLER

Use your round brush to paint the left antler, using the same colors and techniques as in step 3.

EYES AND EARS

Indicate the eyelid and add a white highlight to the eye. Check the ears, making sure the back of each ear is highlighted.

LIGHT HAIR

Continue texturing the moose's coat, adding white and Yellow Oxide to show the lighter hair color on the shoulder.

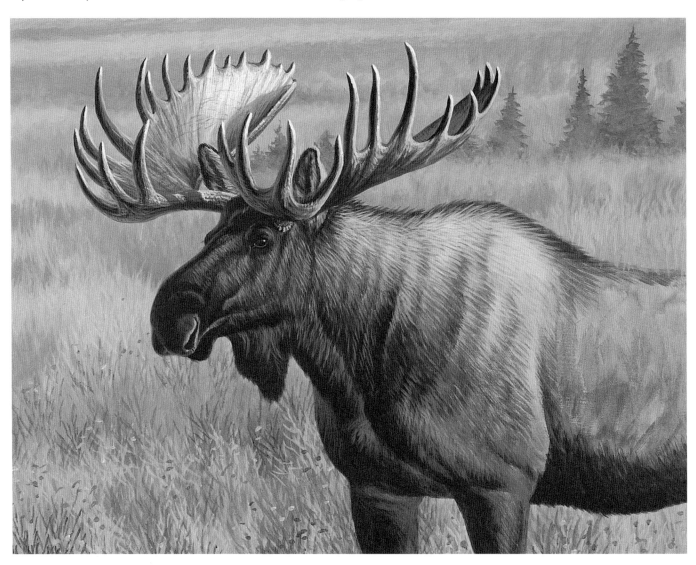

FACE AND NECK

Indicate details on the face and neck with white and Raw Sienna beneath each muscle and tendon and around the nostril; wash these areas with Burnt Umber if they get too light.

HIGHLIGHTS

Mix Alizarin Crimson and Ultramarine Blue with a little white and use delicate strokes to show the highlights on the nose, jaw, the bell under the throat, the lower half of the neck and the point of the shoulder.

SHADED AREAS

Paint the shaded side of each leg and the belly with Burnt Umber and Payne's Gray.

STEP 4: *Finish the Head, Fill In the Body*

Blend the facial structures with feathery brushstrokes. Add more color to the body and shoulder with your flat brush.

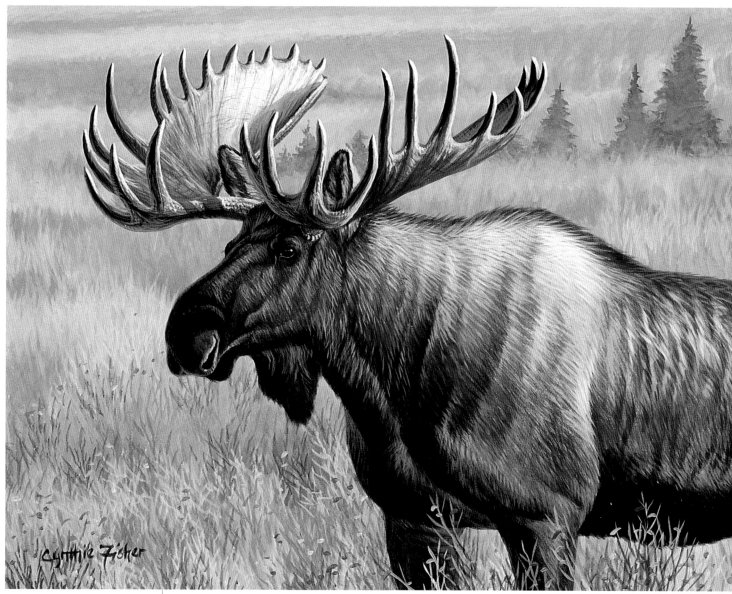

Autumn Splendor
Acrylic on hardboard
12" × 16" (30cm × 41cm)

STEP 5: *Add Final Touches*

Indicate the furrowed coat pattern on the back with alternating bands of Burnt Umber and white, mixed with Raw Sienna. Wash any areas that seem too dull with Raw Sienna, mixing in Alizarin Crimson on the lower body. Touch up the dark areas with more Payne's Gray and Burnt Umber.

Because of the darker colors used in this painting, a final coat of varnish really brings the colors to life!

Background

Add a few twigs and leaves around the bull with your round brush, using white, Raw Sienna and Burnt Sienna. Blend colors in the distance to create depth, using alternating soft bands of purple and yellow. Add some Phthalo Green to Raw Umber and indicate a few distant trees. Detailed vegetation around your subject gives him life and a clearer sense of his habitat.

Painting a Bull Caribou

Caribou live in habitats similar to those chosen by moose, and with their multicolored coats and tremendous antlers, they make an impressive subject for a painting. This demonstration features a bull in his autumn regalia, posing on a shady afternoon in late fall tundra.

MATERIALS

Surface
Gessoed hardboard panel, stone gray

Paints
Burnt Umber
Raw Umber
Raw Sienna
Payne's Gray
Ultramarine Blue
Phthalo Blue
Phthalo Green
Yellow Oxide
Alizarin Crimson
Titanium White

Brushes
Round: no. 6
Flat: no. 4

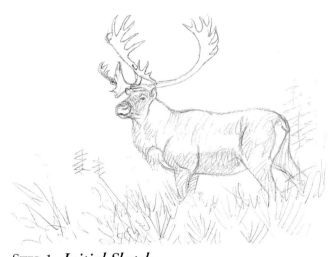

STEP 1: *Initial Sketch*
Sketch a pose that shows off a caribou's best features.

Reference photos

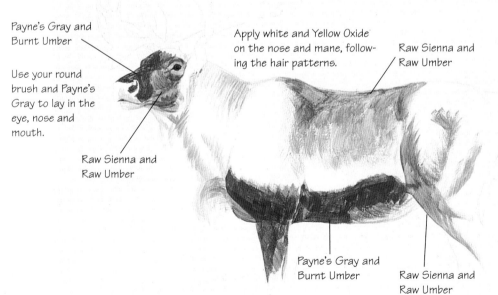

Payne's Gray and Burnt Umber

Use your round brush and Payne's Gray to lay in the eye, nose and mouth.

Apply white and Yellow Oxide on the nose and mane, following the hair patterns.

Raw Sienna and Raw Umber

Raw Sienna and Raw Umber

Payne's Gray and Burnt Umber

Raw Sienna and Raw Umber

STEP 2: *Lay in Base Colors*
After transferring your sketch to your painting surface, begin the initial color application with your flat brush.

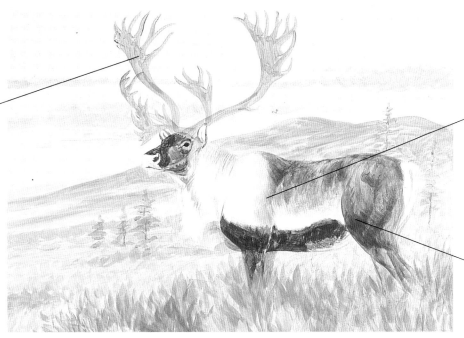

Apply Raw Sienna with your round brush to indicate the antlers.

Use a mix of Ultramarine Blue and Raw Sienna to indicate the shadow behind the bull's shoulder.

Add a little Ultramarine Blue and a touch of Alizarin Crimson to Raw Sienna and Burnt Umber and wash this mixture over the hindquarter muscles with your flat brush.

STEP 3: *Continue Color Application*

Follow the bull's muscle structure as you lay down washes of paint. Add some texture detail to the hair along his side.

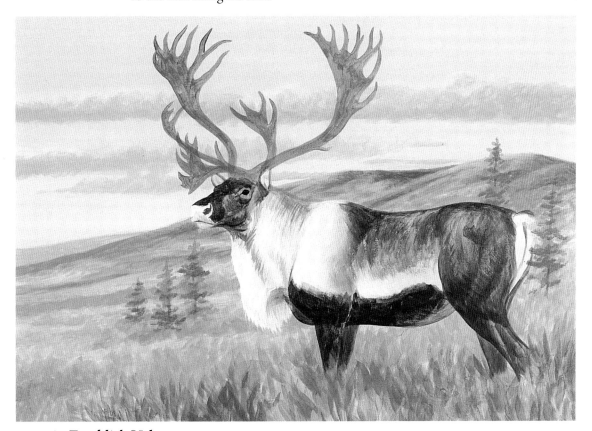

STEP 4: *Establish Values*

Repaint and darken the caribou's body using the same colors as before, washing over the initial layer with more pigment.

RIGHT ANTLER
Paint a dark Payne's Gray/Burnt Umber mix on the tips of his right antler and underneath each separate antler plane, feathering this color in with Raw Sienna to the main body of the antler. Add white highlights on the antler beam and curved tips.

HIGHLIGHTS
Use white and Ultramarine Blue on top of the muzzle, indicating reflected light from the sky; add a highlight to the eye.

LEFT ANTLER
Add Payne's Gray and Burnt Umber underneath the main beam and on the tips and lighter values on top, leaving a few streaks to show texture.

SHOULDER/NECK
Apply short vertical strokes of white and Raw Sienna on his shoulder and neck.

NECK
Show more folds in the neck with short strokes of Burnt Umber mixed with white

FACE
Wash the face with Burnt Umber, following the facial structure.

DARK AREAS
Apply short vertical strokes of Burnt Umber in the dark areas.

BACK/HINDQUARTER
Wash the bull's back and hindquarters with more Raw Sienna and Burnt Umber.

LEGS
Indicate more muscle groups in the fore and hind legs with Burnt Umber and Payne's Gray.

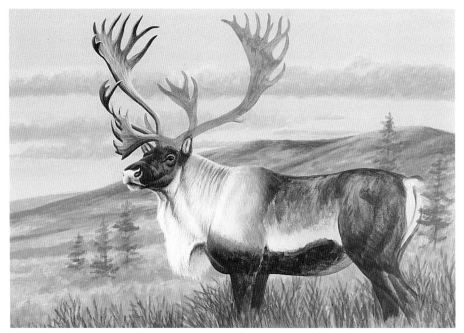

STEP 5: *Begin Detailing*

Keep the values strong on the far antler. Add texture and folds to his coat with your round brush.

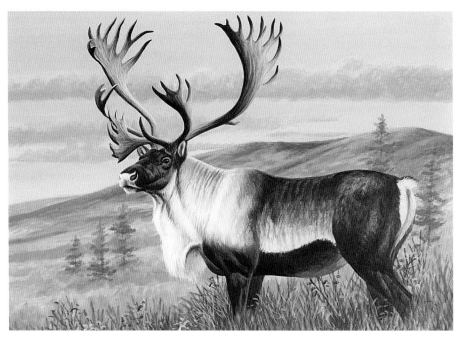

STEP 6: *Finalize Body Values*

Continue to darken the bull's brown and black coat areas, creating a rich deep brown and a velvety black on his underside, blending into the lighter areas of his side and neck.

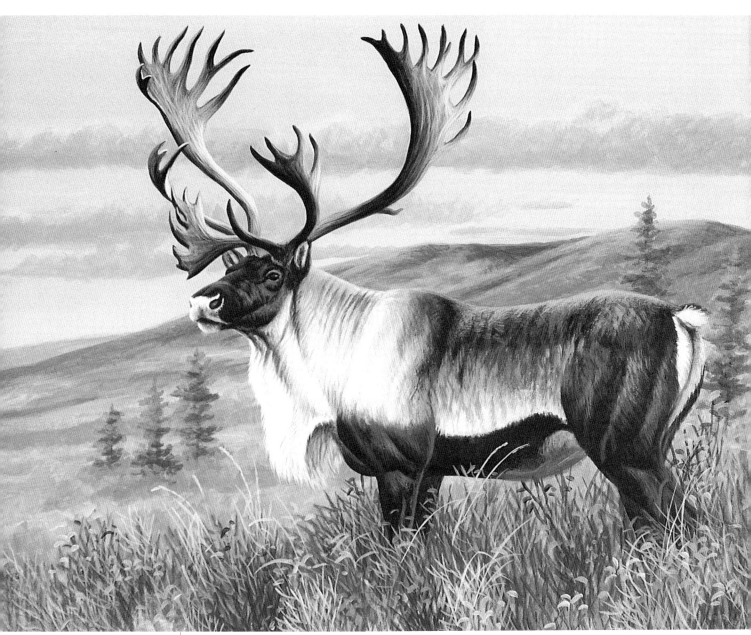

Tundra Nomad
Acrylic on hardboard
12" × 16" (30cm × 41cm)
Private collection

Step 7: *Add Final Touches*

Use your round brush with a mixture of white, Ultramarine Blue and a touch of Alizarin Crimson to paint reflected light on the bull's back, as well as on the larger muscle groups of the legs. Add some more hair details to the bull's mane, using more Ultramarine Blue and Burnt Umber in the shadow areas.

Background

Use Phthalo Blue and Phthalo Green mixed with earthy colors to portray the distant mountains and trees, as well as the colors of the vegetation, placing the caribou in his typical habitat.

Sketching Sheep

Sheep can be a lot of fun to draw and paint, but they can present challenges as well. Luckily, they are fairly easy to approach in certain areas, and it isn't too difficult to get detailed photos of their various features. Sheep give an impression of stockiness and a compact build, with short strong legs and a stoic demeanor. Their horns are their trademark feature, with the curl pattern requiring some study.

Stocky!

Blocking in Shapes
Because sheep are fairly compact, it helps to use circles and ovals to indicate the major quadrants of the body. Start with three circles showing the head position, forequarters and hind end. Add circles for the horns and a small one indicating the muzzle. Add lines for the legs, keeping their position back from the brisket area. Give the knees a slight bend, as sheep rarely stand with their front legs totally straight. Show a few muscles in the hindquarters. Because of their thick coats, their musculature isn't well defined.

Annual rings

Horn Structure
The rings follow the horn's curves, and there are darker rings, indicating each year of the ram's lifetime, spaced along the horn length.

Sheep have large, somewhat expressionless eyes, accentuated by the oval pupil within the pale iris. The muzzle is small and neat, with large cleft lips and two tidy upswept nostrils.

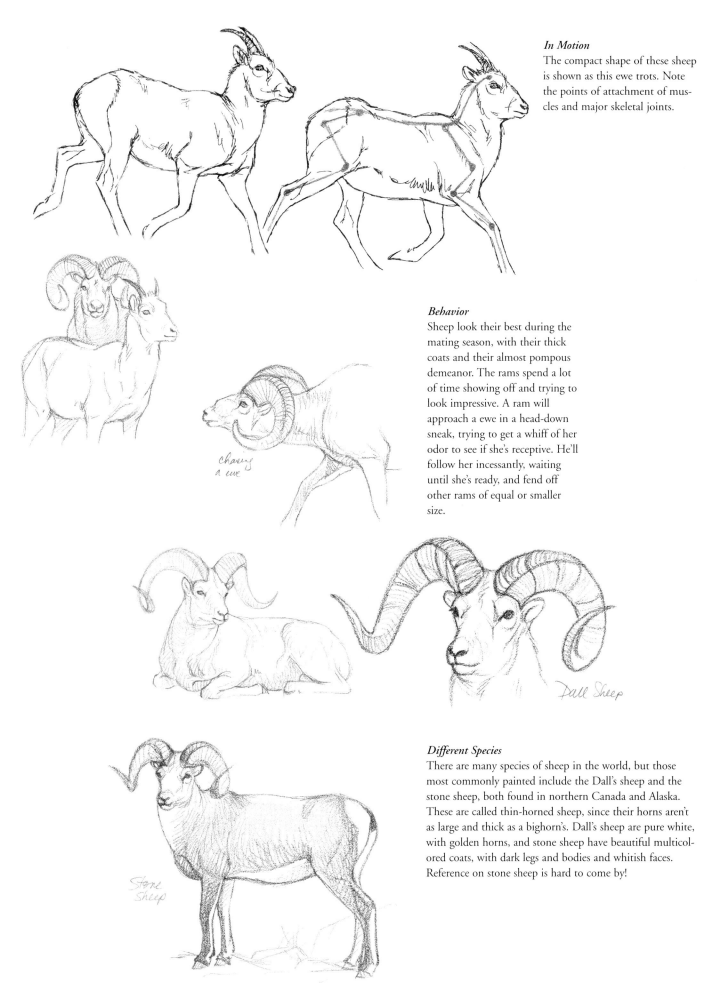

In Motion
The compact shape of these sheep
is shown as this ewe trots. Note
the points of attachment of mus-
cles and major skeletal joints.

Behavior
Sheep look their best during the
mating season, with their thick
coats and their almost pompous
demeanor. The rams spend a lot
of time showing off and trying to
look impressive. A ram will
approach a ewe in a head-down
sneak, trying to get a whiff of her
odor to see if she's receptive. He'll
follow her incessantly, waiting
until she's ready, and fend off
other rams of equal or smaller
size.

chasing
a ewe

Dall Sheep

Different Species
There are many species of sheep in the world, but those
most commonly painted include the Dall's sheep and the
stone sheep, both found in northern Canada and Alaska.
These are called thin-horned sheep, since their horns aren't
as large and thick as a bighorn's. Dall's sheep are pure white,
with golden horns, and stone sheep have beautiful multicol-
ored coats, with dark legs and bodies and whitish faces.
Reference on stone sheep is hard to come by!

Stone
Sheep

Painting Marco Polo Sheep Horns

Marco Polo sheep are found in the mountains of Asia and are one of the largest sheep in the world. The curl and texture of their horns are very similar to those of North American sheep. The Marco Polo is a truly magnificent example of a wild sheep!

Reference Photo
A local taxidermy shop is a great source for detailed reference gathering.

MATERIALS

Surface
Gessoed hardboard panel, stone gray

Paints
Burnt Umber
Yellow Oxide
Raw Sienna
Ultramarine Blue
Phthalo Blue
Payne's Gray
Titanium White

Brushes
Round: no. 2
Flat: no. 4

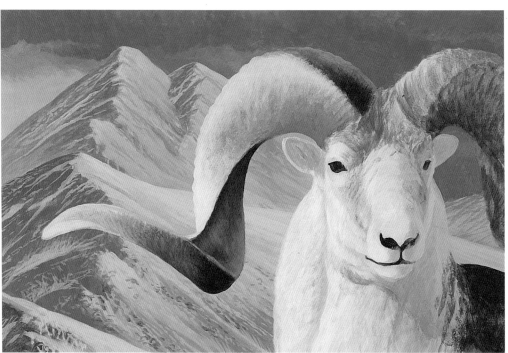

STEP 1: *Define the Horn Shape*

Using your flat brush, blend Raw Sienna with Burnt Umber on the shadowed side of the horn and Raw Sienna, Yellow Oxide and white for the sunny side. Use Burnt Umber and Payne's Gray along the line that separates the two sides.

Where the horn curves into the light, use a lot of white with Yellow Oxide. To show reflected light on the back of each curve, mix Phthalo Blue with white and brush the top and inside of the horn.

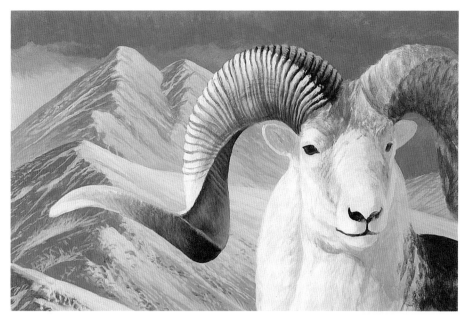

STEP 2: *Start on the Horn Rings*

Paint Burnt Umber stripes within the horn, perpendicular to the rings. Use your round brush to place rings, making some wider and darker than others. Follow the different planes in the horn's curve with the rings, to make the horn look round. Add a few dark lines to indicate age rings. Mix white and Yellow Oxide to accent the top edge of the horn where it meets the shaded side. Do the same on the shaded top of the horn with a white/Ultramarine Blue mix, keeping it random, to imitate chips and cracks in the horns.

STEP 3: *Finish the Horn*

Since the rings get fainter toward the end of the horn, make your lines a little lighter. Keep a sharp eye on the different planes and curves; if your rings aren't painted right, the curl of the horn won't look correct. Accent the inside of the horn with Yellow Oxide and Raw Sienna, since the bright sunshine on the ram's neck will reflect on his horn.

Sketching Pronghorn Antelope

Pronghorns are unique in North America and indeed the world as they are not true antelopes, nor are they true goats, but something in between. They are incredibly beautiful animals, found on the plains and prairies of the western states. Built for speed and endurance, they have a deep chest with large lungs and heart, and slender legs that are wiry and strong. Pronghorns' lovely coloration and the wide-open spaces they call home make them an attractive subject matter to paint.

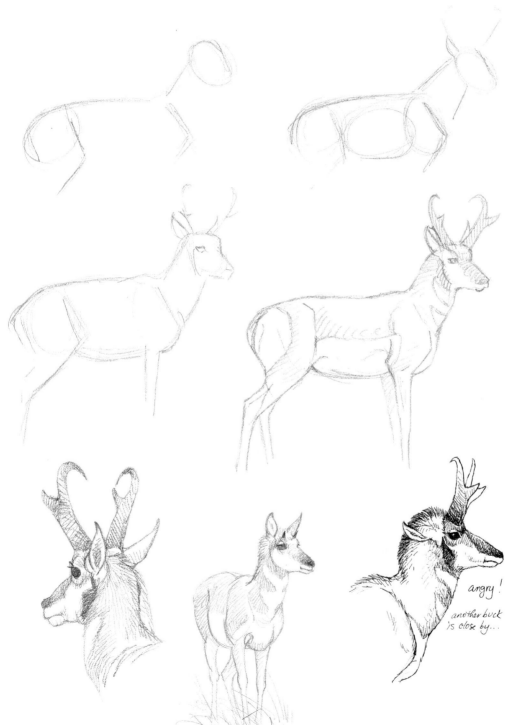

Defining Outline
Start with a line diagram that shows shoulder and knee joints, as well as the spine, and draw a circle for the head. Join the lines with ovals to indicate the major muscle groups and belly, and start sketching the horns and ears. Continue filling in the form, adding lines for the legs and checking the eye and nose position. To finish, draw the distinctive coat patterns, beef up the horns, and add a few muscles in the legs and rump. Keep the legs slender, and study the fur patterns on the rump and sides.

Practicing Poses
Practice drawing all angles, and don't forget to try drawing the does; antelope are gregarious, and you usually encounter them in small groups. The female has the same coat pattern as the male, but lacks the black patch along the jawline. She also has a much lighter face and muzzle than the buck.

angry!

another buck is close by...

Painting Pronghorn Coat Patterns

In this abbreviated study, we'll concentrate on capturing the bright color and coat patterns of the pronghorn antelope, trying not to overwork the texture in the hair, but allowing the initial washes to show through and maintain the intensity of the color.

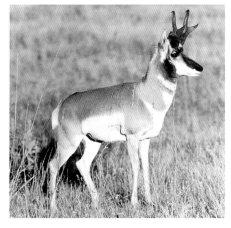

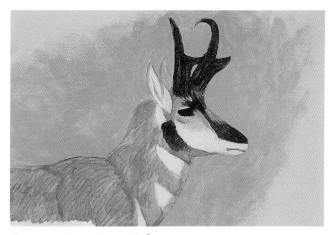

STEP 1: *Lay Base Colors*

Lay on a fairly thick coat of Raw Sienna with your flat brush, following the direction of the hair. Add white on the throat and facial markings, shading underneath these patches with Raw Umber. Lay in the dark face mask and horns with Payne's Gray and Burnt Umber, using your round brush.

MATERIALS

Surface
Gessoed hardboard panel, stone gray

Paints
Burnt Umber
Burnt Sienna
Raw Sienna
Raw Umber
Payne's Gray
Yellow Oxide
Ultramarine Blue
Titanium White

Brushes
Round: no. 4
Flat: no. 6

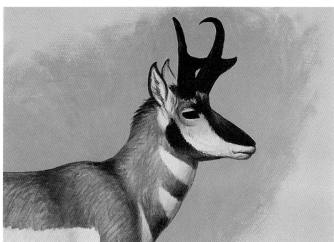

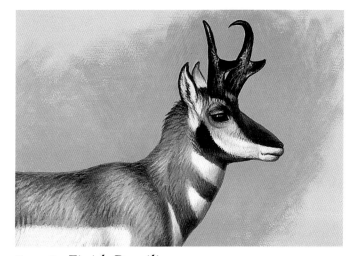

STEP 2: *Start Texturing*

Define the buck's outline with soft brushstrokes of Raw Sienna and Burnt Sienna, emphasizing where the shoulder joins the neck. Wash the face around the eyes and along the nose with Burnt Sienna. Darken the black areas again, and outline the ears with Burnt Umber. Add a touch of Ultramarine Blue to the shadow areas on his neck and side, and delineate the mouth and eye with Burnt Umber and Payne's Gray.

STEP 3: *Finish Detailing*

Use delicate strokes of Burnt Sienna and Burnt Umber to detail the neck, back and shoulder. Highlight with a few lighter hairs with white, Raw Sienna and Yellow Oxide. Indicate the jaw muscles and structures around the eye and horns. Add Ultramarine Blue and white as reflected light on the buck's nose and back. Finish the eye with a highlight area. Drybrush highlight areas onto the horns with white, Burnt Umber and Ultramarine Blue, adding a little Raw Sienna to warm the tone. Keep white areas bright.

6

OTHER HOOVED ANIMALS *of the* WORLD

The antelope, gazelles, sheep and other hooved animals found in Africa and Asia represent the vast majority of big-game species, and their coat patterns, horns and habitats present every possible combination.

Gathering your own reference on these animals can be a challenge. However, there are an increasing number of affordable photographic safaris being offered, some tailored directly to the artist's needs.

Zoos, museums and trophy collections are another, cheaper, reference source for the artist. While they offer nice close-up opportunities for photographs, you will have to adjust your sketches to take into account the differences between captive or stuffed specimens and those in the wild.

Patterns in the Grass
Acrylic on hardboard
30" × 40" (76cm × 102cm)

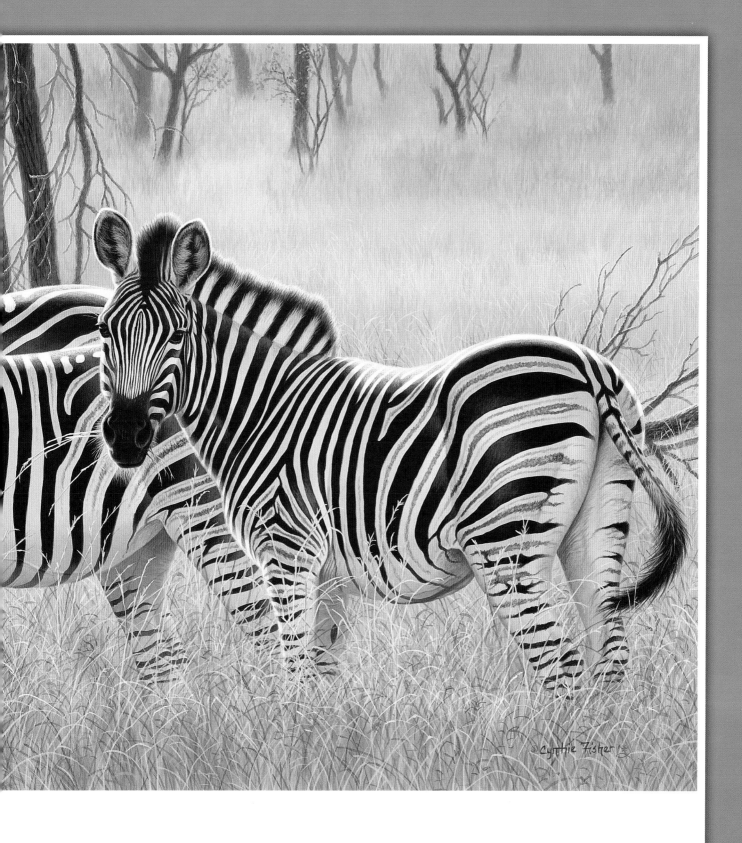

Cynthie Fisher

Sunlit Fur—Waterbuck Antelope

In this demonstration, we'll concentrate on hair texture in bright direct sunlight. Waterbuck have thick, shaggy coats, more similar to some North American species, with white accents, including a "bull's-eye" around their rump. The males sport lovely ringed horns.

MATERIALS

Surface
Gessoed hardboard panel, stone gray

Paints
Burnt Umber
Burnt Sienna
Raw Umber
Raw Sienna
Yellow Oxide
Ultramarine Blue
Phthalo Blue
Phthalo Green
Dioxazine Purple
Payne's Gray
Titanium White

Brushes
Round: no. 6
Flat: no. 4, no. 6, no. 10

Create an Exciting Composition

The majority of big-game paintings that feature more than one animal often have an odd number of animals, such as three, five or seven. This adds interest and avoids the possibility of a static, paired composition.

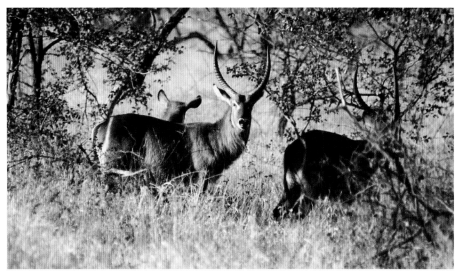

Reference Photo
All that's needed to use this photo as the idea for a painting is the addition of more detail for the face and horns of the male and additional reference for the females and background. This photo provides information on the lighting and coat colors used on all three animals, as well as the habitat for the background.

STEP 1: *Initial Sketch*

Determine a pleasant placing for the three animals, with emphasis placed on the bull and his long horns.

BASECOAT
Use a mix of Raw and Burnt Umber for the base.

HIGHLIGHTS
Add purple in highlight areas.

NECK AND FACE
Wash the necks and faces with Raw and Burnt Sienna.

SHADOWED FUR
Keep the back and shadow areas of the shoulder and hip dark with Burnt Umber and Ultramarine Blue washes.

COWS
Keep the cows more subdued with Phthalo Blue and Raw Umber on their faces and ears.

BULL DETAILS
Paint white on the bull's face and sunlit ear.

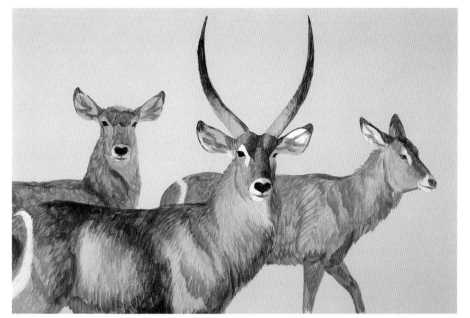

STEP 2: *Establish Values*

Transfer your sketch to your painting surface. Keeping in mind the light direction coming in from the left, lay in the waterbuck, using your flat brushes for the body and your round brush for eyes, ears and horns. Be sure to follow the hair patterns with your flat brushes.

BACKS/NECKS
Using your round brush, brush the top of the cows' backs and necks with white mixed with Phthalo Blue, Burnt Umber and a little purple, allowing much of the initial paint coat to show through.

FACIAL DETAILS
Add dark accents of Burnt Umber and Payne's Gray around their ears, nose and forehead, painting texture in the ears and on their neck fur.

SHADOWED FUR
Paint the shadow areas under their necks with white, Phthalo Blue and Burnt Sienna. Show the sun hitting the cow on the right by adding white on her facial markings.

STEP 3: *Develop the Cows*

Keep the cows' details and values light to accent the bull.

Texture the horns by carefully painting the rings, using a dark stripe for each ring and then accenting each with a light band through the middle of the ring, keeping it lightest on the left side. Add whitish highlights between rings, keeping the right side dark. Wash the horn's base with Raw Umber.

FACIAL DETAILS

Darken and detail the eyes, ears and nose, highlighting the left side more than the right, and add white on his sunlit ear, eyebrow and muzzle.

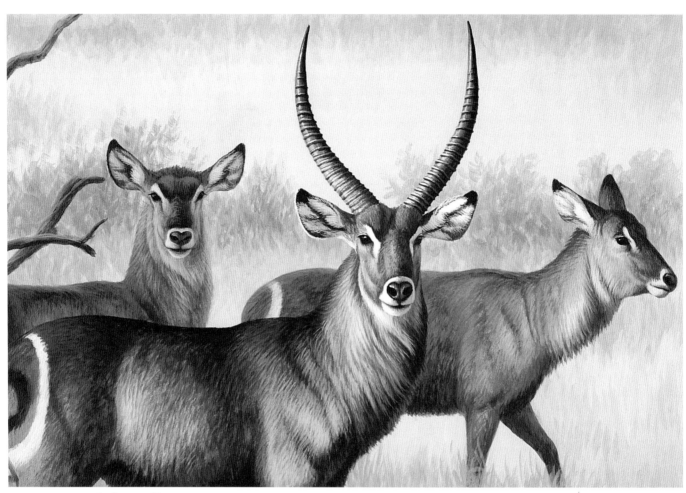

STEP 4: *Detail the Bull*

Use your round brush to add hair texture and details, keeping values fairly strong on the bull and following the direction of his hair.

SHADOWED FUR

Darken the shadow areas of the bull's back, neck, head and shoulders with Burnt Umber and Payne's Gray, showing texture on his neck.

TEXTURE THE FUR

Texture his coat with Burnt Umber on his middle and neck, white mixed with purple and Raw Umber on his shoulder and belly.

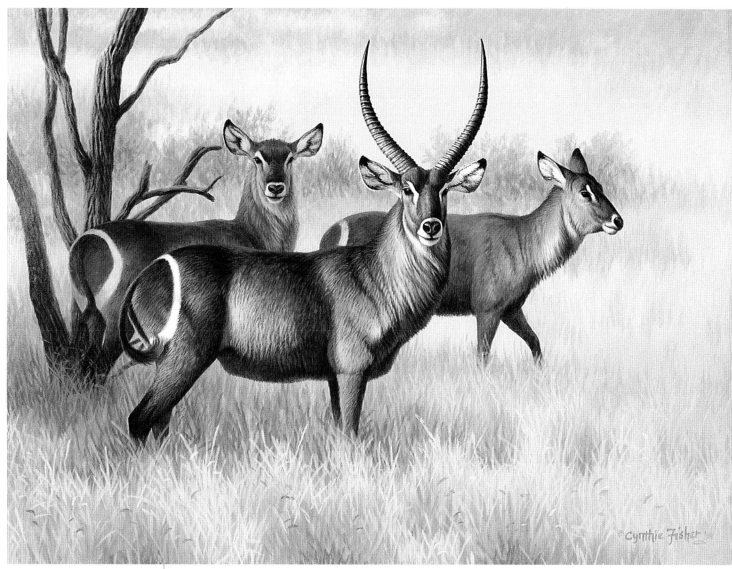

Waterbuck
Acrylic on hardboard
16" × 20" (41cm × 51cm)

STEP 5: *Finish the Bull*

Continue texturing his coat, alternating dark hairs along the top of each fold and muscle, and light hairs in the highlight areas; detail the bull's coat more than either cow's, since he's the center of attention. Wash his neck with Raw and Burnt Sienna. Add reflected light along his back and below his elbow with white mixed with Phthalo Blue and Raw Umber, using your round brush.

Background

With this painting, the emphasis is on the antelope, and the background is handled very loosely using Yellow Oxide and Phthalo Green as well as your other palette colors, with minimal detail and not a lot of colors in the grass. This is a good way to draw all the attention to your subject, not the setting.

Backlit Fur—Nyala Antelope

Another elusive and beautiful species from Africa, nyala prefer dense, thick brush and grass, where the bulls usually live alone or with a few females.

Painting a dark subject with backlighting, as in this demonstration, is tricky, and reference photos are often underexposed due to the sun's angle on the dark animal. That's where a painting can be so much better than a photograph, since the artist can manipulate colors and enhance the subject.

MATERIALS

Surface
Gessoed hardboard
 panel, stone gray

Paints
Burnt Umber
Burnt Sienna
Raw Umber
Raw Sienna
Yellow Oxide
Ultramarine Blue
Phthalo Blue
Phthalo Green
Dioxazine Purple
Payne's Gray
Titanium White

Brushes
Round: no. 6
Flat: no. 4, no. 6,
 no. 10

Reference Photo
Because nyala tend to be secretive and shy, it can be difficult to capture a good likeness with your camera. Luckily, you can combine your own photo attempt with other references from books and zoos. Here, the backlighting shining through the nyala's ears and on his face and horns was the catalyst for this painting, even though there's not much of him showing in the photo.

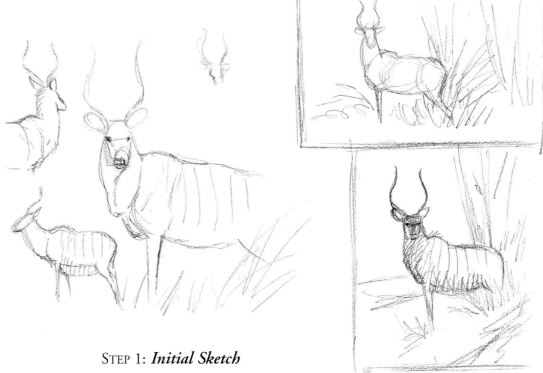

STEP 1: *Initial Sketch*

Try several formats and layouts with your sketch, placing the subject in horizontal and vertical formats. A vertical format seems to show off the nyala's pose and horns the best.

HORNS AND FACE

Lay the ears, horns and face in first, using your round brush. Paint Burnt Umber and Payne's Gray on the shaded sides, white and Raw Sienna on the sunlit sides.

HIGHLIGHTS

Use white and Raw Sienna for the highlight areas on his face, horns and the hair along the back.

BODY COAT

Use a mixture of Raw and Burnt Umber with a little Ultramarine Blue and your no. 4 flat brush for his body, adding Burnt Sienna on his lower half.

EARS

Use Burnt Sienna and a touch of purple for his ears.

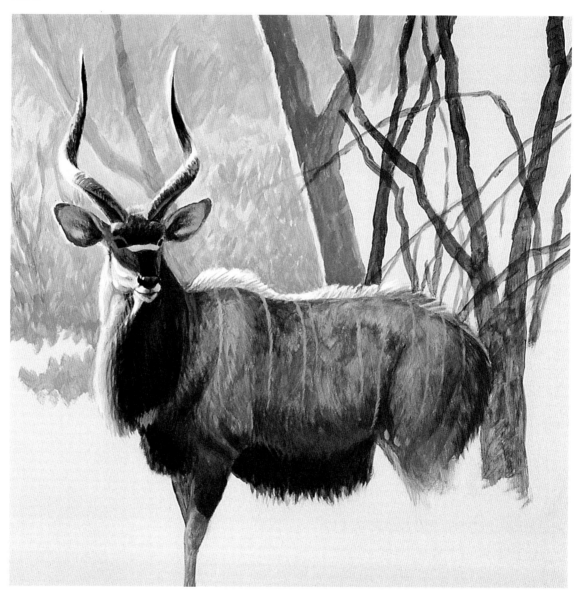

SHADED WHITES

Use white mixed with Phthalo Blue and Burnt Sienna for his white patches that are shaded.

LONG FUR

Follow the long hair patterns beneath his body and on his neck, adding Payne's Gray to make a rich black.

STEP 2: *Initial Lay-In*

Remember your source of light as you wash in color.

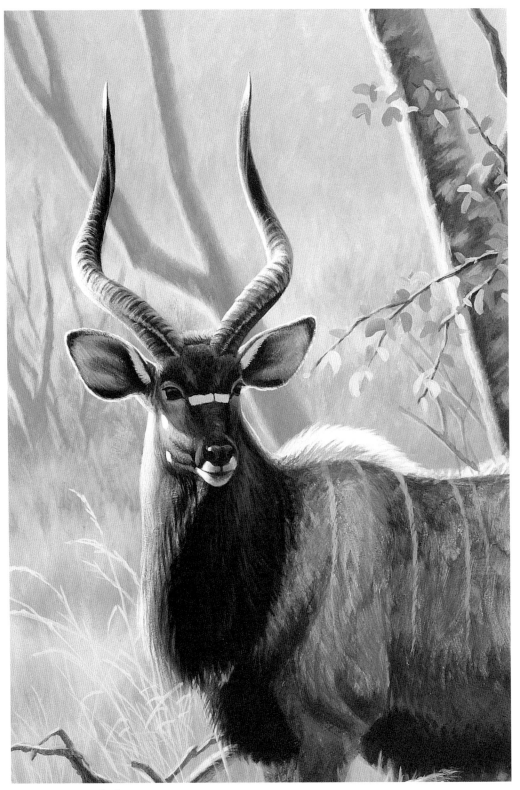

HORNS

Finish the horns, detailing first the darker areas with Burnt Umber and Payne's Gray and adding lighter accents and highlights with white and Raw Sienna. The horns spiral upward, so, indicate that pattern with reflected light on the back of them.

EARS

Keep the ears bright, adding a white edging around them.

HIGHLIGHTS

Highlight the sunny side of the neck and face with white, Raw Sienna and Raw Umber, while keeping the core of the shadow on his neck almost black.

REFLECTED LIGHT

Paint reflected light on his neck, nose and shoulders with a mix of white, Ultramarine Blue and Burnt Sienna.

STEP 3: *Detail the Face*

Use your round brush to detail the bull's horns and face.

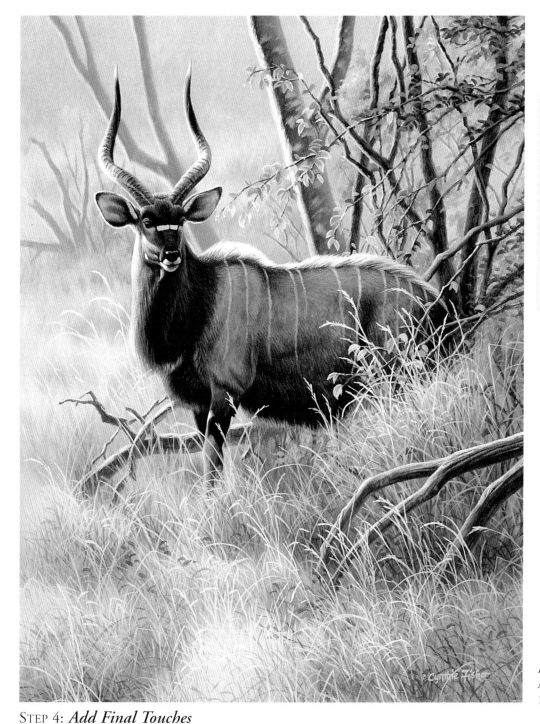

Background

The level of detail in the background is minimal behind the antelope and strongest around and beneath the subject, so that the viewer's attention isn't drawn away from the point of interest. Add Yellow Oxide and Phthalo Green to your palette for background colors, and make use of your no. 10 flat brush.

Forest Prince
Acrylic on hardboard
16" × 23" (41cm × 58cm)

STEP 4: *Add Final Touches*

Finish the bull's body by emphasizing the muscles in his forequarters and along his side with Burnt Umber and Payne's Gray. Wash the top of his back using a no. 6 flat with a mix of Ultramarine Blue, white and Burnt Sienna, indicating hair and coat texture. Do the same with his lower body using a darker color mix of Burnt Umber and Payne's Gray.

Touch up the white strips on his side with white, Phthalo Blue and Raw Umber, following the curves of his body with your round brush.

Keep the long hair on top of his back bright with white and Raw Sienna.

Complete his legs, which have a small white spot halfway up and are Raw Sienna on the lower half.

Soften and blend edges.

Zebras

Here is a demonstration that literally copies a photograph, changing only an ear position and the overall lighting. Zebras aren't antelope or deer, but they are certainly exotic and a real treat to paint due to their stripes. It's not hard to get good photos of zebras, either in the wild or at a zoo or game park.

MATERIALS

Surface
Gessoed hardboard
 panel, stone gray

Paints
Burnt Umber
Burnt Sienna
Raw Umber
Raw Sienna
Yellow Oxide
Ultramarine Blue
Phthalo Blue
Phthalo Green
Payne's Gray
Titanium White

Brushes
Round: no. 6
Flat: no. 4, no. 6,
 ½-inch (12mm)

Reference Photo
There is enough detail in this photo to complete a painting, but the lighting is very flat.

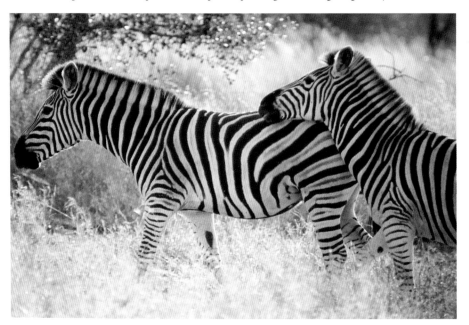

Lighting Reference
This picture gives great ideas on lighting for zebras, showing all the rich colors in the mane and on the belly that result from backlighting. It is easy to combine the animals in one photo with the lighting in another, creating a more interesting image.

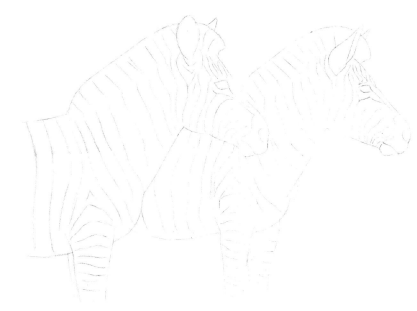

STEP 1: *Initial Sketch*

This painting is almost taken directly from the reference photo (top, facing page). I projected the image onto tracing paper and carefully redrew the stripe patterns. I moved the ear on the left zebra forward a bit, as well as the whole animal, to bring the zebras' faces closer together.

Paint a white edge around their heads, back and lower bodies with your round brush, washing the white with Raw Sienna.

Use your no. 4 flat to blend this white edge color into a warm orange, mixed from Raw and Burnt Sienna, and using your no. 6 flat, indicate the major muscle groups in the shoulders, neck and on the face.

Paint the muzzles and eyes with Payne's Gray and Burnt Umber using your round brush.

Keep the underbody and legs very yellow with washes of Raw Sienna.

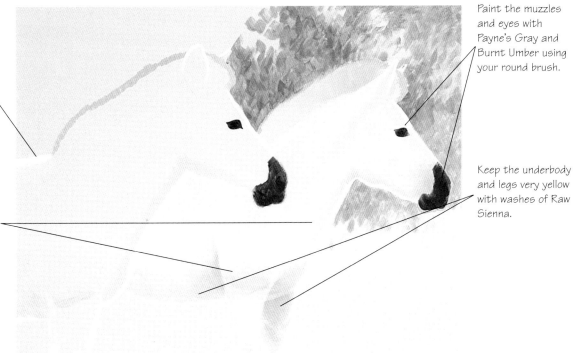

STEP 2: *Decide Values*

The warm gray gesso is actually very close in color to the backlit zebra reference and becomes the base coat for the animals.

The zebras are painted as if they are fat white ponies without stripes, and the colors must be kept bright, since most of the light area will be covered by the dark stripes.

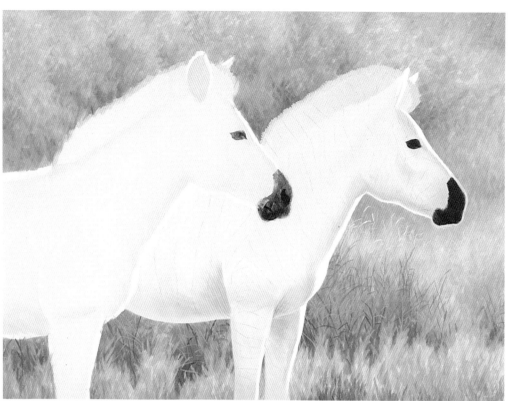

STEP 3: *Complete Base Colors*

Finish the base color of the zebras, adding Phthalo Blue to white and Burnt Sienna on the back. Brush the reflected light areas like shoulder blades, neck muscles and cheekbones with white and Phthalo Blue using your no. 6 flat.

Transfer the stripes on the back zebra by tracing/redrawing the stripes from your initial sketch onto the zebra.

STEP 4: *Begin Stripes*

With a mix of Burnt Umber and Payne's Gray, use your round brush to lay in the stripes. Pay attention to your reference, as the stripes follow a definite pattern. Follow the contours of his head, neck and mane, since this will show the structure and make him seem "round."

Replace the dark paint with Raw and Burnt Sienna where the sun strikes the coat. Paint the top of the mane white, and wash it with Raw Sienna, adding Burnt Umber beneath where the sun shines through the mane.

STEP 5: *Finish the Stripe Pattern*

Continue laying in the stripes, fading them out where the sun hits his neck and face. Repaint most of them with the same dark mixture, getting it as dark as you can, especially on his face and neck. Make sure you follow the pattern in the mane, tilting the lines to reflect the hair standing up.

After you've darkened the stripes, use your round brush to paint on white mixed with Ultramarine Blue on the tops of muscles and bony structures to show reflected light from the sky. These areas include the neck, jaw, above the eye and around the nostril and lips.

Texture the mane by repainting the light areas with white, Phthalo Blue and Burnt Sienna, and wash the backlit hair on top with Raw and Burnt Sienna.

Add a very subtle highlight to the eye with white, Burnt Sienna and Phthalo Blue.

STEP 6: *Add Details*

The details you add here help create the illusion of light and give dimension and life to your zebra.

Add a few whiskers around and under the muzzle with white, using your round brush, and wash them lightly with Raw Sienna.

Wash the lower jaw area and forehead, where the highlight meets the shadow, with Raw Sienna.

Buddies
Acrylic on hardboard
12" × 16" (30cm × 41cm)

STEP 7: *Add Final Details*

Wash the area between the two zebras with some white and Raw Sienna to distinguish between them and push the zebra on the right back a little. Add a few wrinkles behind the front legs and in the chest area with your round brush.

Background

Keep this background simple with bright colors that complement the subject (try adding Raw Umber, Yellow Oxide and Phthalo Green to your palette). The only real detail should be in the grass around the hooves. Paint it with a ½-inch (12mm) flat brush, using quick random brush-strokes and dots to indicate seed heads and leaves. Leaving some areas without detail will create a more "painterly" look.

7

CREATE
FINISHED
PAINTINGS
step by step

Once you are familiar with your subject matter, the medium and the techniques used in rendering your ideas onto the board or canvas, all that remains is to come up with a strong composition. This is certainly an ongoing challenge to all artists, no matter how accomplished they are! Not only is it your responsibility as the artist to render the animals as accurately as possible, you also should have access to the correct habitat reference and know enough about the species you are painting to draw them in an interesting pose or behavior.

Placing your chosen subjects in a pleasing composition can be accomplished by a lucky first instinct or by long careful study of compositional rules. But rules are sometimes made to be broken, and experience, along with helpful critiques, can be the greatest teacher for the artist.

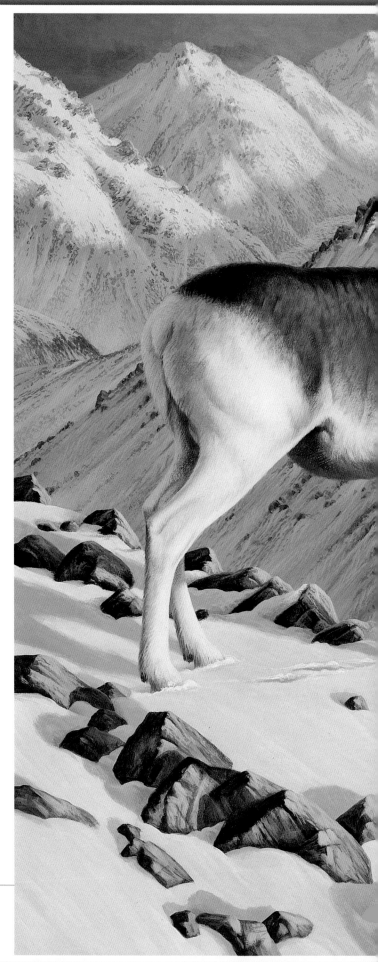

Above the Clouds
Acrylic on hardboard
24" × 30" (61cm × 76cm)

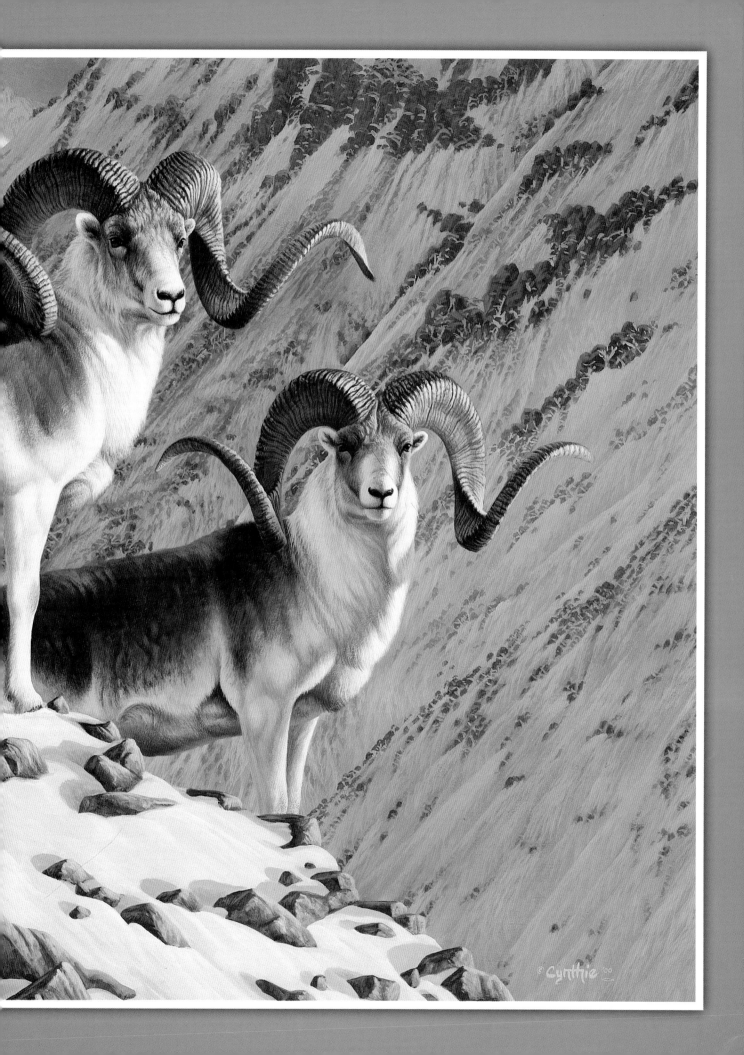

Whitetails in the Forest

Because painting backlighting is difficult, we'll focus on another example of this technique, featuring whitetails confronting the viewer in an eastern birch and hardwood forest.

Gathering Reference
Although the photos of the deer show how light bounces off a deer's coat, the sunlit areas tend to come out overexposed and too white; luckily, you can fix that in your painting.

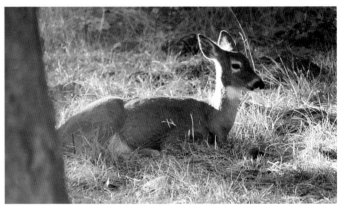

MATERIALS

Surface
Gessoed hardboard panel, stone gray

Paints
Burnt Umber
Burnt Sienna
Raw Umber
Raw Sienna
Yellow Oxide
Alizarin Crimson
Ultramarine Blue
Phthalo Blue
Payne's Gray
Titanium White

Brushes
Round: no. 4, no. 6
Flat: ½-inch (12mm), no. 6, no. 8, no. 10, no. 16

Other
Grumbacher glossy oil and acrylic spray varnish

As for background reference, these two photos show a hardwood forest in Minnesota and an aspen thicket in British Columbia. Both have features that can be useful in depicting the mixed stand of trees shown in this painting. These features can be combined with other photos to provide enough information to successfully portray the setting in this painting.

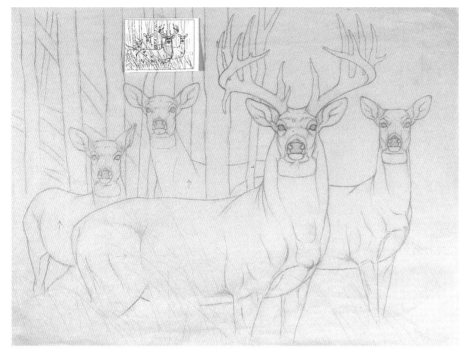

STEP 1: *Initial Sketch*

Increasing the size of a sketch by hand is certainly possible and very good practice, but it does save enormous time and energy if you enlarge the sketch before transferring it.

As you transfer your sketch to your painting surface, move the subject around as necessary for a better composition. Here, the two does on the left are moved up a bit from the initial sketch.

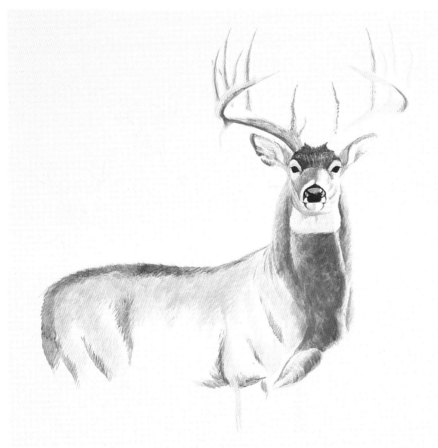

STEP 2: *Begin the Buck*

Start with a mix of white and Yellow Oxide and paint all the sunlit areas on the buck with your no. 6 flat and round brushes. Make sure you're confident in your light source, which in this case is coming from the upper right corner and slightly behind the deer.

With a mix of Burnt Umber and Burnt Sienna, delineate some of the major muscle groups, outline the back and rump, and add a few shadows to the antlers.

Paint the eyes, nose and mouth with Payne's Gray, using your no. 4 round brush.

Show the reflected light on the buck's back with your no. 10 flat and a mix of Phthalo Blue, Burnt Sienna, white and Alizarin Crimson, staying more blue near the top.

Fill in his neck and forehead with Burnt Sienna and Burnt Umber washes, washing Raw Sienna on the area where the sunlight meets the shaded side.

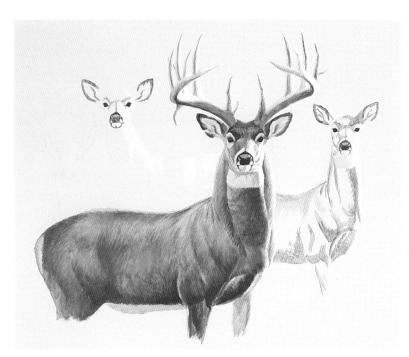

STEP 3: *Continue Laying in Deer*

Finish filling in the buck's body, staying blue on top and adding Burnt and Raw Sienna on his lower half as a reflection from the grass. Add Burnt Umber and accent his shoulder muscles with your no. 10 flat. With your round brush, fill in his antlers with Burnt Umber, adding Raw Sienna washes on the sunlit areas. Darken the brisket area between his front legs with Payne's Gray, following the hair patterns. Indicate the light areas under his chin and around his eyes with white mixed with Raw and Burnt Sienna. Continue washing his body with Burnt Umber and Raw Sienna, keeping it bright and warm.

Work on the does, showing the sunlit areas first, then filling in some of the muscles and adding reflected light on the back using the same colors and brushes as you did with the buck.

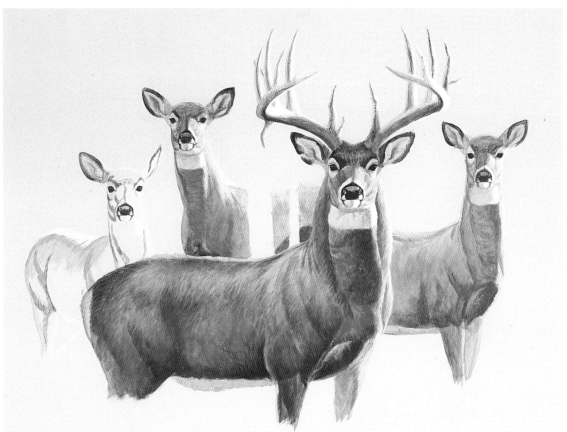

STEP 4: *Continue Work on the Does*

Using your no. 6 and no. 10 flats, wash the does with Burnt Umber, keeping them a little duller in color than the buck by adding some Ultramarine Blue and Raw Umber to the wash. Keep using blues and a little Alizarin Crimson on the shaded side of the does to show reflected light.

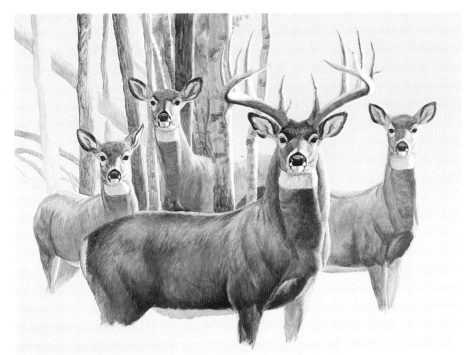

Start painting the trees with simple brushstrokes, using your flat brushes. Lay in the birches with white, Phthalo Blue and Raw Sienna, with a little Burnt Umber next to the highlight areas.

The hardwoods are a mix of Burnt and Raw Sienna and Ultramarine Blue, with white and Raw Sienna highlights.

Try lots of color mixes in the background between the trees, using Alizarin Crimson, Ultramarine Blue, Phthalo Blue, Raw and Burnt Sienna, and just a little white.

STEP 6: *Continue the Background*

As you cover the background, let the different colors blend with rough, random brushstrokes, keeping the overall tone redder as you get closer to the ground. Keep the farthest trees very vague, only hinting at texture. Add Raw Sienna and a pale green mixed from Yellow Oxide and Phthalo Blue in the distance, and start detailing tree branches, using Burnt Umber and your round brushes.

STEP 7: *Finish the Background*

Continue with Burnt and Raw Sienna into the foreground, adding crimson near the bottom. Follow the grass patterns with broad brushstrokes, using your largest flat brush and washes of Raw Sienna and Raw Umber. Fill in gaps in the background, feathering the patches of different colors together.

Add distant trees with simple strokes of Burnt Umber and Raw Sienna, adding a highlighted side to each tree.

Start indicating the detail behind the deer in the forest, using your no. 6 round, and adding random twigs, leaves and stems with Burnt Umber, Raw Sienna, white and Yellow Oxide, keeping them dark against light areas and light against dark bark.

Using your ½-inch (12mm) flat, add sunbeams coming in from the upper right with a mixture of white and Raw Sienna, keeping the paint fairly faint. After adding those, repaint the trees, darkening previous values and adding texture to the bark with your no. 6 round brush.

Paint in a few shadows from overhead branches on the tree trunks, using your no. 6 flat and the shade color from each tree.

Add some breath around the deer with a dry brush, using white and Raw Sienna.

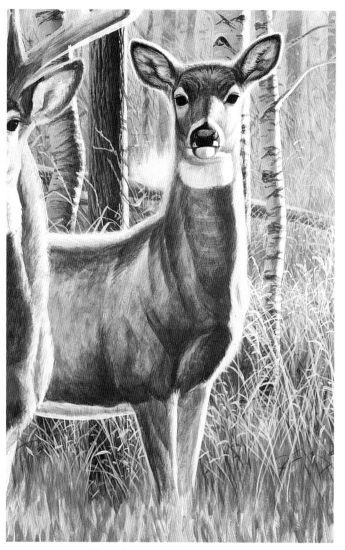

STEP 8: *Deepen Doe Coloring*

Enhance the overall tone of the doe on the right with washes of Raw and Burnt Sienna. Repaint her outline with white and Raw Sienna, using your tracing to retransfer any part of the outline you can't see through your background paint.

STEP 9: *Develop the Doe*

Continue washing the doe's back with Raw Sienna and Burnt Umber, leaving some of the purple tone showing through.

Accent her shoulder muscles and the folds in her neck with Burnt Umber, using your no. 6 flat.

Detail her ears and forehead, first softening the sunlit edge with white and Raw Sienna, then washing it with Raw and Burnt Sienna. Paint the darker areas in her ears with Burnt Umber and a touch of Payne's Gray. Then paint the hair patterns inside her ears, using your no. 6 round and white mixed with Ultramarine Blue and Burnt Sienna.

Repaint her eyes and nose with Payne's Gray, as well as the outer ear edge, feathering this dark edge into the sunlit hair.

Add Ultramarine Blue and Alizarin Crimson mixed with a little white along the top of her head and down to the nose.

Wash her right cheek with Raw Sienna, indicating some of the jaw structure.

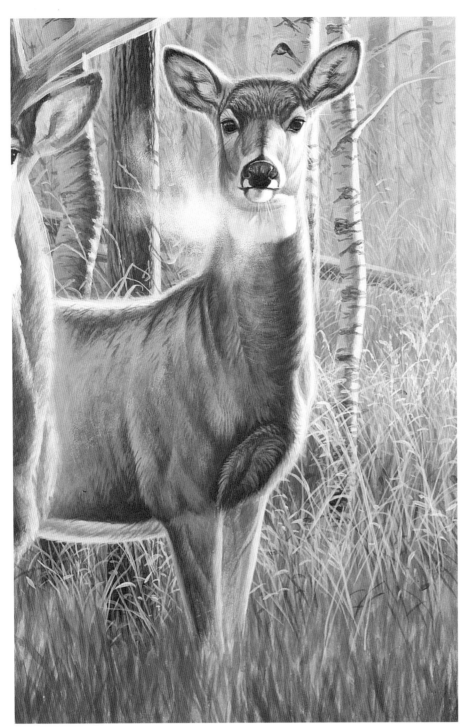

STEP 10: *Finish the Doe*

Finish by adding some hair details and texture to the doe's brisket area and elbow with your round brushes, using white mixed with Raw Sienna and Alizarin Crimson.

Add Ultramarine Blue to that mix and apply reflected light along her shoulder blade and on top of her back, allowing some of the initial Raw Sienna/Burnt Sienna wash to show through.

Follow the hair contours around her neck with your round brush, alternating lights and darks to create texture. Keep the brightest colors right next to the highlights on her back, neck and face, and then add the darkest accents of Burnt Umber and Payne's Gray next to that.

Finish her face by adding reflected highlights of Ultramarine Blue and white to her nose and left eye and brighter highlights of white and Yellow Oxide to her nose and eye on the right.

Using your no. 4 round, add a few whiskers above the eyes and around the muzzle.

Add pure white to her throat patch and nose markings, and using a dry-brush technique, add the breath with white, Raw Sienna and Yellow Oxide.

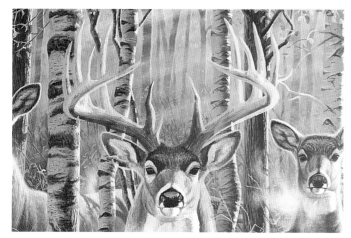

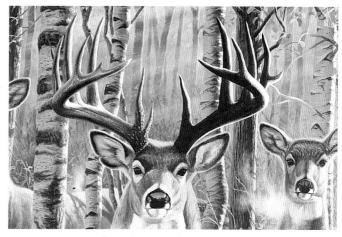

STEP 11: *Work on the Buck's Head*

Using your round brushes and a mixture of white and Raw Sienna, repaint the outline of the buck's face, neck and antlers, indicating a notch in one ear. Use Phthalo Blue, white and Raw Umber to repaint the shaded side of the antlers.

STEP 12: *Develop the Buck's Head*

Using your round brushes, paint the antlers with Burnt Umber, leaving the highlight areas white. Work with the left antler, using a Phthalo Blue/Raw Umber/white mix to show reflected light. Add Raw Sienna to show the shine on the shaded side. Keep the sunlit side almost pure white, washing with Raw Sienna near the core of the shadow. Add bumps and ridges near the antler base with Phthalo Blue, white and Burnt Umber. Keep the forward sweeping antler tine the darkest, washing the lower edge with Burnt Sienna.

Finish the buck's left ear, keeping the outer edge soft. Detail the hair inside with your round brushes and a mix of white, Phthalo Blue and Raw Umber.

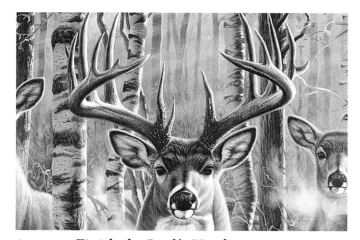

STEP 13: *Finish the Buck's Head*

Paint the buck's right antler using the same techniques as in step 12.

Detail the left side of his face with your no. 6 flat, using Burnt Umber and Raw Sienna to define his facial muscles.

Use Ultramarine Blue mixed with white, Alizarin Crimson and Raw Umber to paint reflected light on the shaded side of his head and neck. Use your round brush to paint individual hairs on his forehead, keeping them brown in the middle with washes of Raw and Burnt Sienna. Add dark cracks in the hair with Burnt Umber and Payne's Gray.

Darken the eyes and nose, and add eyelids and reflected light with your round brush and a mix of Ultramarine Blue, white and Burnt Sienna. Keep the highlight in the eye and on the nose subdued on the shady side and bright on the sunny side. Add whiskers and enhance the sunlit throat, chin and muzzle with pure white.

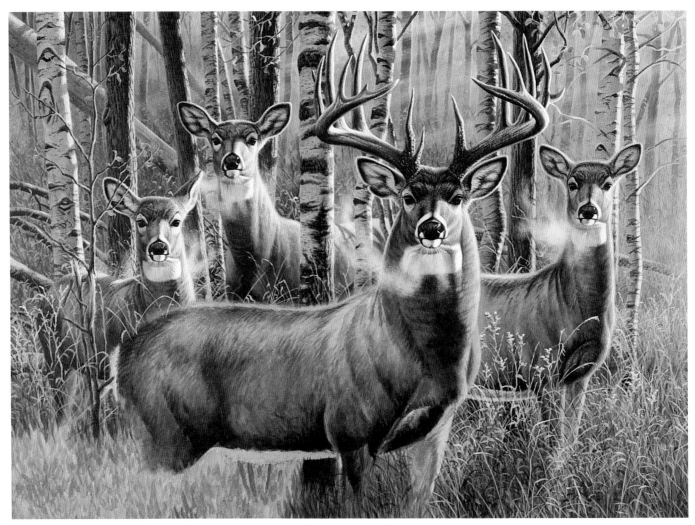

STEP 14: *Develop Deer and Foreground*

Paint the other does in as you did in steps 8–10, remembering your source of light, and keeping their values a little lighter than the buck's.

Using your no. 6 flat, darken the buck's neck with washes of Burnt Umber, Raw Sienna and Burnt Sienna, following the hair around in a circular pattern.

Add reflected light on his left side, and keep the sunny side bright with washes of Raw Sienna.

Drybrush breath in with white and Yellow Oxide.

Wash shaded patches in the foreground grass with Burnt Sienna and Alizarin Crimson, and add twigs and grass stems with Burnt Umber, using your round brushes.

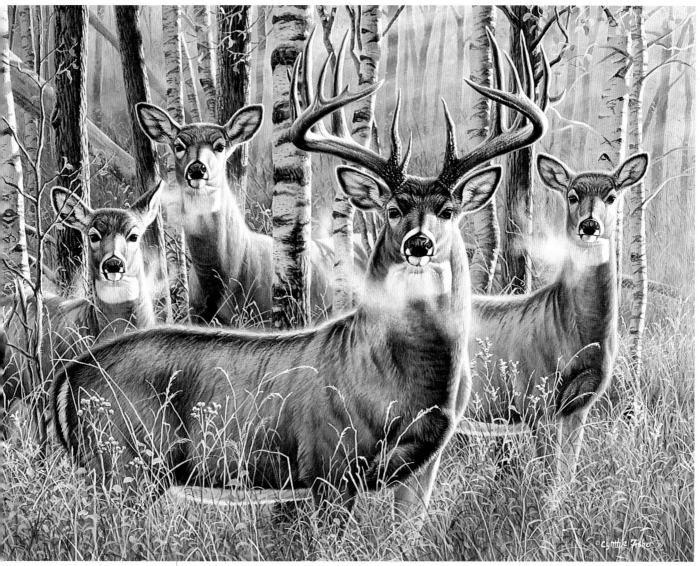

Sudden Encounter—Whitetails
Acrylic on hardboard
24" × 32" (61cm × 81cm)

STEP 15: *Add Final Touches*

Continue darkening the buck's body, using Burnt Umber beneath each muscle and joint and next to the white belly marking. Show some of the coat texture near the elbow and in the brisket area with a mix of white, Raw Sienna and Burnt Umber, changing to a purple mixture of Ultramarine Blue and Alizarin Crimson on the upper half of the body. Use Phthalo Blue and white on the top of his back, switching to darker accents of Burnt Umber to show cracks and texture in his coat. Keep the top of his back soft and bright, washing this edge with Raw Sienna. Finish the buck's hindquarters, darkening with washes of Burnt Sienna and Alizarin Crimson.

Start painting grass and weeds in the foreground, using your round brushes and beginning with Phthalo Blue, white and Burnt Sienna. After the blue stems, switch to a mix of white, Raw and Burnt Sienna. Finish with the brightest grass stems with white and Yellow Oxide. Paint some weedy stems and leaves with your round brush, washing these areas with Raw Sienna to make them brighter.

Follow the directions on your varnish once your painting is complete. Varnishing will bring out the richness of your paints.

Elk in the Snow

This demonstration shows how to place your elk into a setting. We'll focus on strong lighting, accenting both the subjects and their snowy environment.

Gathering Reference
It's important to gather detailed photos of body parts, good lighting and the environment.

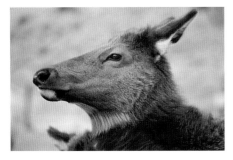

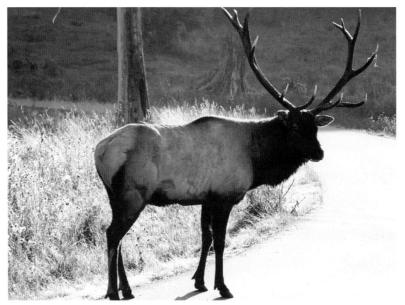

MATERIALS

Surface
Gessoed hardboard
 panel, stone gray

Paints
Burnt Umber
Burnt Sienna
Raw Umber
Raw Sienna
Yellow Oxide
Acra Violet
Ultramarine Blue
Phthalo Blue
Payne's Gray
Titanium White

Brushes
Round: no. 4, no. 6
Flat: ½-inch (12mm),
 no. 6, no. 8, no.10,
 no. 16

Other
Grumbacher glossy
 oil and acrylic spray
 varnish

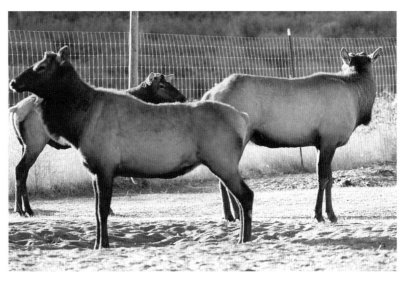

STEP 1: *Initial Sketch*

This sketch shows a herd of elk moving down a slope in the trees, with the bull elk looking behind his shoulder, out at the viewer.

STEP 2: *Finalize Your Composition*

While the initial sketch is dramatic, I wasn't happy with the angle of the bull's head and the shape his turned antlers made in the sky, so I changed his head position, making him look out into the valley. Add fallen trees and tracks in the snow to emphasize how the hill slopes down, anticipating the shadows that would darken the lower right half of the painting due to the backlighting.

STEP 3: *Transfer Your Sketch*

After enlarging your sketch onto tracing paper, flip the paper over and retrace the sketch with a soft pencil and transfer it to your board. Take this opportunity to reposition animals or trees that seem too close together, or perhaps too close to the edge of the board, by moving the tracing paper around a little and retransferring the part you wish to change.

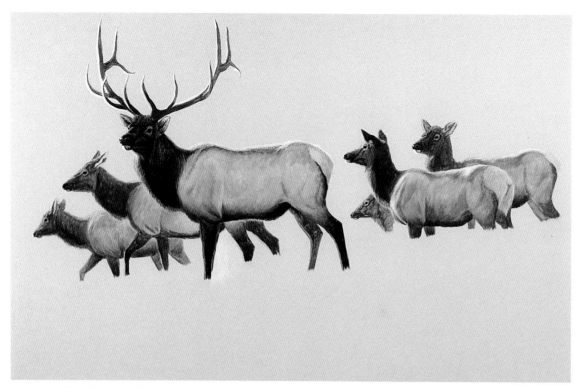

STEP 4: *Lay in Initial Colors*

With backlighting in mind, follow your sketch, keeping the values strongest on the bull. Using your no. 10 and no. 16 flat brushes, lay the bull in first, using lots of Burnt Umber and Payne's Gray on his head, neck, legs and belly. Keep his body fairly bright with washes of Raw Sienna, adding Burnt Sienna near his belly.

Mix Ultramarine Blue and a little violet for his upper half, getting dark with Raw Sienna near the top of his back, before adding white and a touch of Raw Sienna on the very top of his back to indicate the light direction.

Lay in the antlers with a no. 6 round, using Burnt Umber on the shadow side and white and Yellow Oxide on the sunlit side.

Wash his face with violet and Burnt Sienna, keeping it fairly intense in color. Paint in the eyes and nose with your no. 6 round.

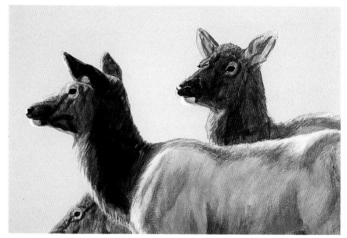

Detail of the Cows

Keep the texture created in your initial coat of paint rough and scrubby with your flat brushes, but following the general anatomy and the direction of the hair. As you paint each animal, keep the values fainter on the ones furthest back to create a sense of distance between each elk.

Use white washed with Raw Sienna on the sunlit areas of the body. Add Burnt Sienna to the wash on the neck. Keep that area where the highlight meets the shadow the most intense in color, using washes of Raw and Burnt Sienna.

Lay in the eye, nose, mouth and ears with your no. 6 round.

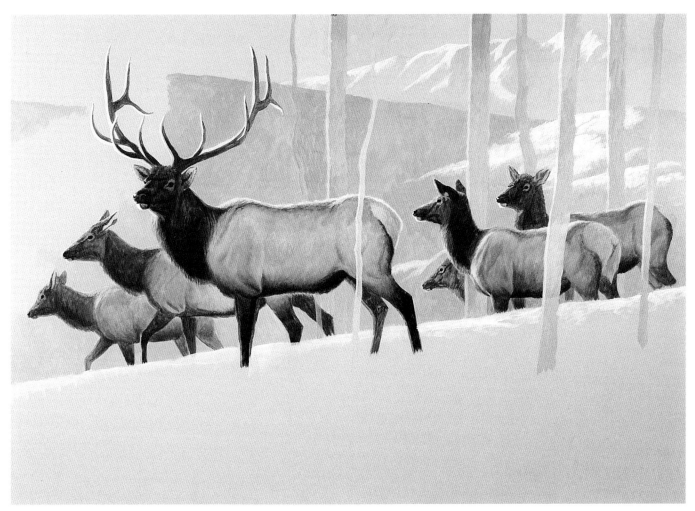

STEP 5: *Begin the Background*

Indicate the tree positions with strong strokes of white mixed with Raw Umber and Ultramarine Blue, adding a white highlight on the left side of each tree using your no. 10 flat brush.

Paint a simple white slope of snow to show the position of the hill.

Mix a warm purple from violet, Ultramarine Blue, white, a little Burnt Umber and a touch of Raw Sienna, and lay in the furthest mountain, leaving unpainted areas of the gessoed board to indicate sunlit slopes. Add a few touches of white to accent these sunny areas.

Darken the purple for each hill as they come closer, adding more blue and violet. Mix a sky color out of Phthalo Blue, white and a little Raw Sienna, and apply the sky with your largest flat brush.

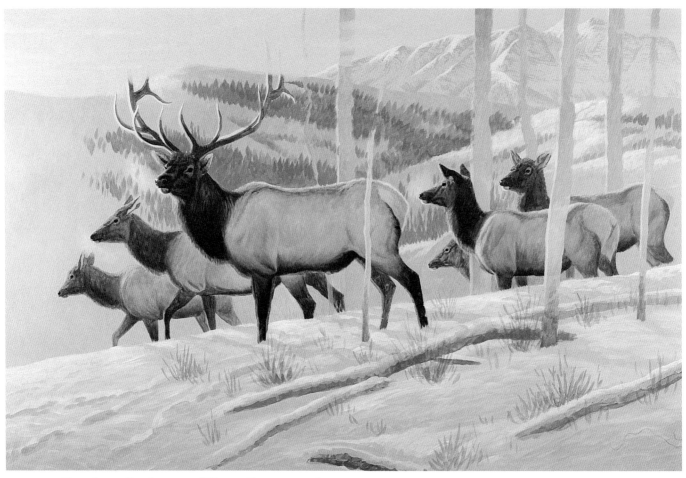

STEP 6: *Continue Background/Start Foreground*

Finish the sky color, painting in long horizontal strokes. You'll cover the trees and antlers, but you'll repaint them later. Add a touch of Raw Sienna and more white to the sky color near the horizon.

Wash the base of the mountain with white and Raw Sienna to push it back a little. Use your no. 6 round brush and a mix of Ultramarine Blue, violet, white and Raw Umber to detail rocks on the distant hills. Mix Ultramarine Blue, violet, a little Phthalo Blue and Burnt Sienna for the distant trees. Using your no. 10 flat, paint in the direction of tree growth, looking for areas to increase the contrast, such as where the bull's sunny back meets the dark hill.

Lay in the fallen trees in the foreground, indicating a few clumps of grass with Raw Sienna and Burnt Umber. Paint shadow areas and the elk tracks with Ultramarine Blue, violet and a touch of Raw Sienna, highlighting the sunny side with white mixed with Raw Sienna, using your flat brushes.

Stay Motivated

The areas of background between the tree trunks, legs and antlers create little "pockets" that you can complete as you go along and gain a sense of accomplishment, something that helps your motivation when painting a large piece like this one.

Indicate far-off bushes on the ground with little brushstrokes.

Mix white, Raw and Burnt Sienna and Burnt Umber with a little Ultramarine Blue to create the distant groves of aspens, keeping branches mostly white and Raw Sienna where the light hits them.

Finish the far cow with pale values, washing her face with violet, white and Burnt Sienna. Add the breath in front of the front cow, using white and Raw Sienna and a very dry flat brush.

Keep the tree values lighter on the more distant hills, darkening them as they get closer with more Ultramarine Blue, violet and Burnt Umber. Detail the trees, adding limbs and branches.

STEP 7: *Work More on Cows and Background*

Use your round brushes to add details to cows and the landscape

Apply white to the front cow, using your round brush and a feathery touch. Wash the white with Raw Sienna on her face and neck.

Detail the foreground aspens by painting the shady side with Phthalo Blue, the middle with Raw Sienna and a little violet, and blend these to the sunlit edge, creating the darkest value where the sun hits the tree by adding Burnt Umber. Mix white and Yellow Oxide for the lit side, and add some trunk details with a mix of Burnt Umber and Payne's Gray.

Add details with Burnt Umber to the middle cow's face, using Payne's Gray on the nose, eye and neck. Wash over the initial paint layer on her back, using white, Ultramarine Blue and violet. Intensify the back highlight, washing white with Raw Sienna.

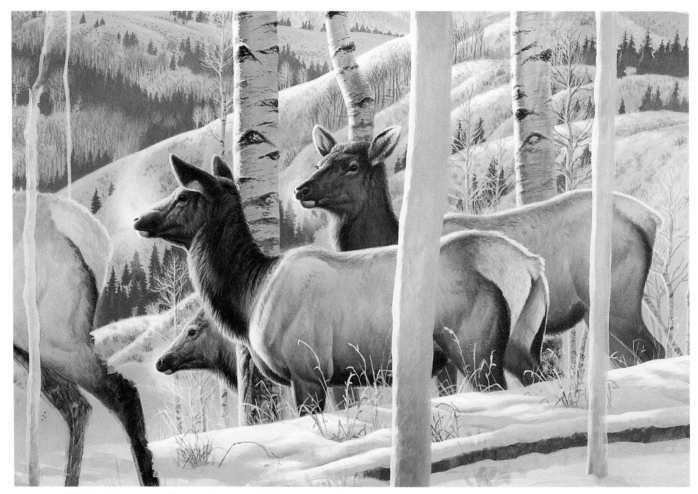

Step 8: *Work More on Front Cow and Foreground*

Add darker details around the rump of the front cow with Burnt Umber and Payne's Gray. Follow her facial structures with your round brush, and add a few hair details to her mane. Try to keep the edges of her outline soft with delicate dry-brush strokes, using white, Raw Sienna and Burnt Sienna. Add some Ultramarine Blue on her back, allowing a few of your rougher brushstrokes to show through and give the illusion of hair and texture.

Using your no. 4 round, paint some grass stems and twigs along the hilltop, using white and Raw Sienna for the lighter ones, Burnt Sienna for the twigs.

After darkening the fallen tree of the foreground with Burnt Umber and Payne's Gray, add the snow on top, using your no. 10 flat and a mix of Ultramarine Blue, violet and Raw Sienna. Wash the sunlit snow areas with Raw Sienna and white, then add pure white on top, leaving some of the Raw Sienna showing through to keep the color warm. Use some white and Phthalo Blue on top of the log where it's shaded.

Use your no. 16 flat, with Ultramarine Blue, Burnt Umber, a touch of Payne's Gray and some white for the clouds. Add Raw Sienna washes to the lower edges. You'll be smudging the outline of the distant mountain, but that's easy to repair. Finish the clouds with more soft, rounded strokes along the tops of each contour, using white mixed with Raw Sienna, a touch of Burnt Sienna and some Ultramarine Blue.

Now that the sky is darker, darken the far mountain with washes of Ultramarine Blue, violet and Burnt Umber, and use your round brush to repaint the mountain edge and some of the details in the rocks and trees.

Using your nos. 6 and 10 flats and lots of paint, mix shades to match the surrounding background and paint out the tree.

Add a tree with your round brush behind the middle cow, further back, keeping the values a lot lighter than those in the near trees.

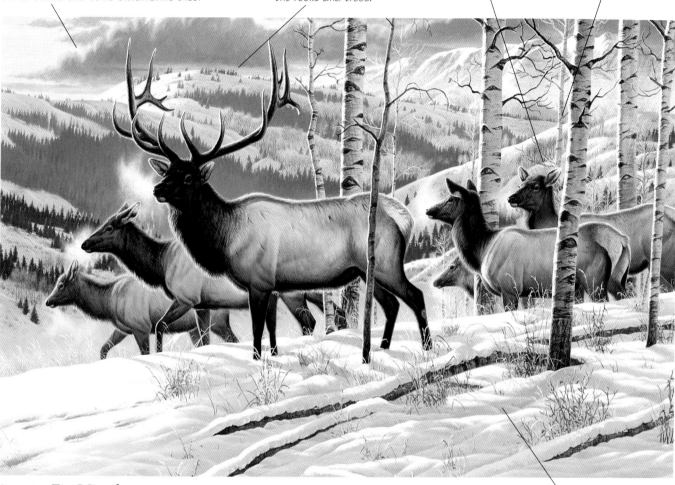

Darken the foreground shadows in the snow with more washes of Ultramarine Blue, violet and white, including a shadow cast from the fallen tree that is up out of the snow.

STEP 9: *Fix Mistakes*

The tree behind the middle cow seems to be growing out of the cow's head. This is a good time to paint it out of the picture and add another, more distant tree to fill the space.

Also, the blue of the sky is overpowering. Some dark clouds would help break up the blue and add drama.

STEP 10: *Work on Calf and Other Cow*

Before detailing these elk, paint a faint "halo" around their outline to soften the edge, using your no. 6 flat and white with Raw Sienna and Yellow Oxide, using a dry-brush technique.

Repeat this step to paint the breath around their heads, adding more white to the color.

Paint the sunlit areas with pure white, using your no. 4 round, and then wash them with Raw and Burnt Sienna, keeping the colors the most intense where the light meets the shaded side.

STEP 11: *Finish Calf and Cow*

Darken the facial and neck anatomy of the cow with Burnt Umber, Burnt Sienna and Payne's Gray, using your round brushes. Allow some of the initial wash to show through in some places, like on her cheek and around the eye.

Use a mix of white, Ultramarine Blue, violet and a touch of Burnt Sienna with your no. 6 round to paint the reflected light on her face and neck, washing the areas with Burnt Umber if they get too light.

Wash the calf's body again with a pale blue wash to push him back, using Ultramarine Blue and some violet with your no. 10 flat.

Add grass blades along the hilltop and over the calf and cow's legs with a mix of white, Raw Sienna and Yellow Oxide, and enhance the cast shadows with Ultramarine Blue and violet, keeping the edges soft.

Repaint the bull's antler outline with a dark mix of Ultramarine Blue, Burnt Umber and Payne's Gray, and add a pure white outline on each tine where the sun hits it, washing all but the tips with Yellow Oxide and Raw Sienna.

Keep the bull's face dark with washes of Burnt Umber and accents of Payne's Gray. Place some reflected light on his forehead and down his muzzle with Ultramarine Blue, violet, white and Burnt Sienna, washing with Burnt Umber if it gets too bright.

Add reflected light to the shaded side of the antlers with white, Phthalo Blue and Burnt Sienna, adding Raw Sienna where the bull's bright coat reflects back onto the antler beam.

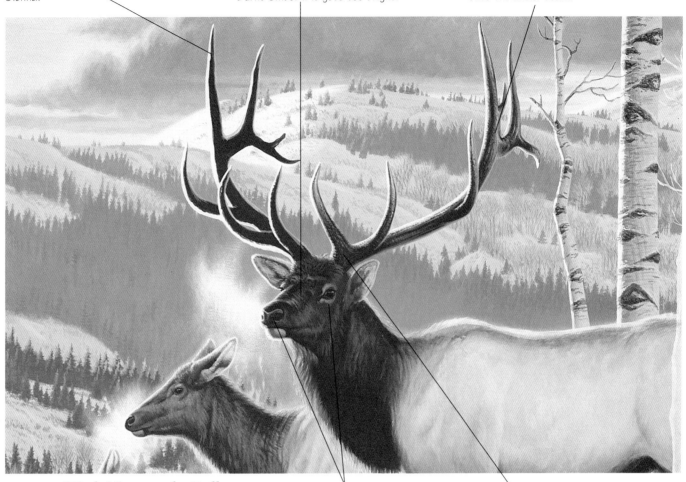

STEP 12: *Work More on the Bull*

Use your round brushes to develop the details on the bull.

Paint his eye, adding a lower eyelid and a subtle highlight with blues and browns. Accent his nose with Payne's Gray, adding highlights with white and Phthalo Blue

Add texture close to the base of his antlers with dots of Phthalo Blue and Burnt Umber.

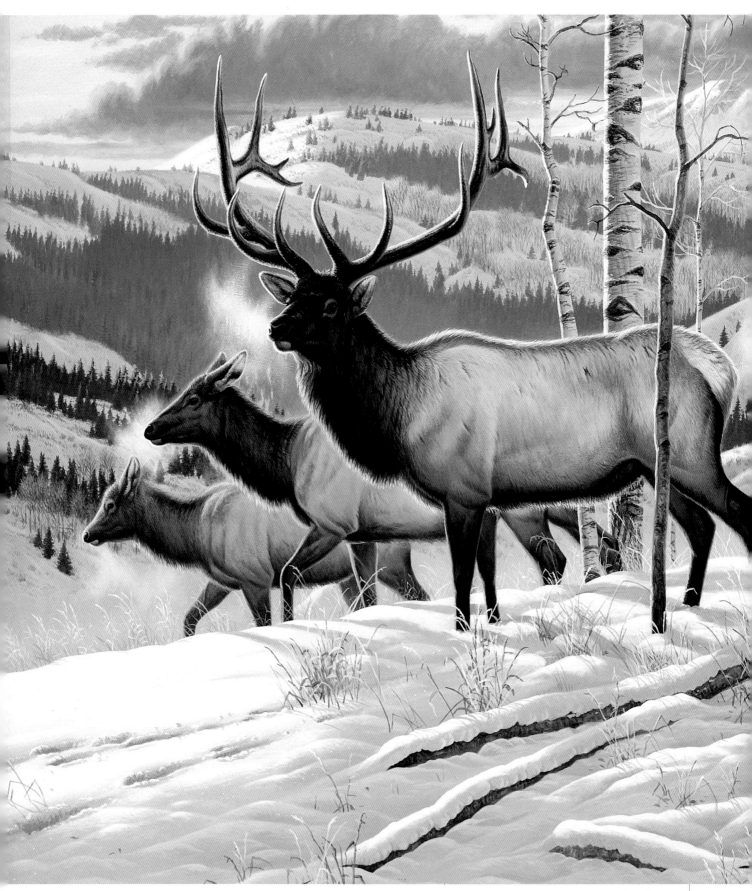

Leading Them Down
Acrylic on hardboard
30" × 44" (76cm × 112cm)

STEP 13: *Finish the Bull and Background*

Wash the bull's sides with a mix of Raw Sienna and Raw Umber near his belly, adding Ultramarine and Phthalo Blue near his back. Keep the areas near the top and bottom of his body the richest in color. Add individual hairs on his belly with white and Raw Sienna, washing that with Raw and Burnt Sienna.

To eliminate any confusion about where his right front leg is, draw and paint it in slightly behind his left front leg, keeping the values on the far legs lighter than the near legs by adding white, Raw and Burnt Sienna washes.

Accent the shoulder and hind-end muscles with soft strokes of Burnt Umber and a touch of Ultramarine Blue.

Add a few cracks and indentations in his coat with your no. 6 round, Burnt Umber and Ultramarine Blue.

Detail his mane with a mix of Raw Sienna, Burnt Sienna and white, following the wrinkles and fur patterns, and adding Ultramarine Blue near the top. Keep the color more intense on the lower half of his neck and more blue on top.

Add the gland and the vein on the hind leg using white, Raw Sienna and a touch of Burnt Umber.

Using your no. 16 flat brush, blend the shaded areas of snow with the sunlit areas, using a mix of white, Raw Sienna and violet, feathering the edges into the darker areas of Ultramarine Blue and violet.

Add bumps and hillocks in the snow by painting the top with a mix of white and Phthalo Blue and the shaded area beneath each with a darker mix of Ultramarine Blue, violet and Raw Sienna. Indicate the tracks with slashes of the purple mixture.

Keep the snow color the brightest where the shade meets the sun, using pure white only on the tops of the logs and each hummock of snow.

Follow the directions on your varnish once your painting is complete. Varnishing will bring out the richness of your paints.

conclusion

I hope this book will inspire you to learn more about the many species of hooved mammals, their behaviors and habitats, and how to successfully paint them. There is an endless variety of these beautiful animals, and a huge number of admirers. Forge ahead and develop your own unique style of painting. Expand your knowledge and experience every chance you get by attending workshops and classes and spending time in the field and at the zoo. And if big game is your fancy, take every opportunity to travel, take photos and learn all you can about them.

I've always said that drawing is the key to success in wildlife art; painting is a technical skill, but drawing comes first. After you are comfortable with your subject, indulge yourself in all the wonderful colors that are at your fingertips; you're only limited by your imagination. Keep it right, keep it bright, and paint!

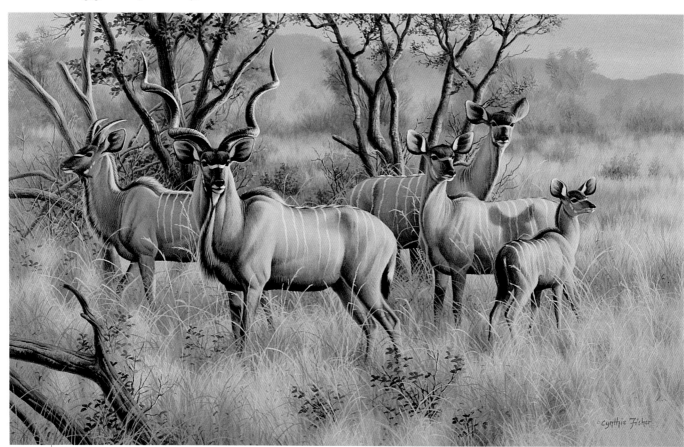

The Gray Ghost
Acrylic on hardboard
18" × 28" (46cm × 71cm)

index